For the Love of Wool

A PRIMITIVE WOOL ARTIST'S CREATIVE JOURNEY

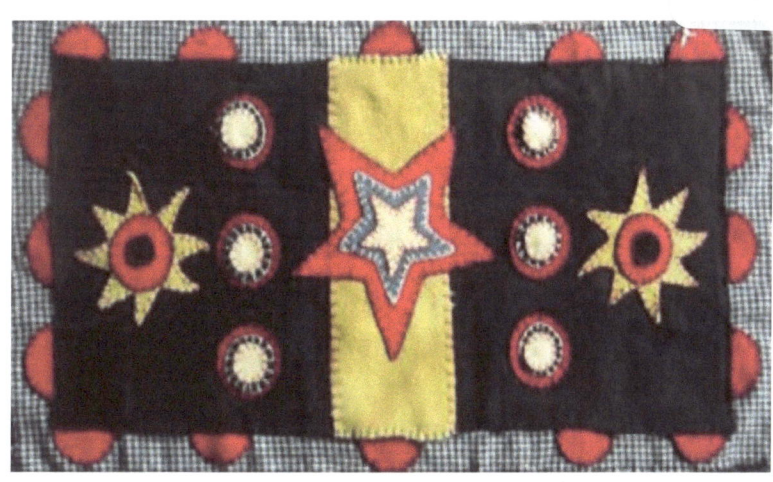

Hooked Rugs, Penny Rugs & "Sailors' Woolies"

CYNTHIA GALLANT-SIMPSON

Copyright 2015 ©
Cynthia Gallant-Simpson

Hesperus ART & INK
Blue Hill, Maine

Publishers of ~

COLORS TO DYE FOR
A PRIMITIVE RUG HOOKERS PHILOSOPHY AND DYEING PRIMER

Email: cynthiagallantsimpson92@gmail.com

website: hesperusfolkartprimitives.com

All author rights will be enforced against use, in any medium, of any material, herein, as protected by copyright.

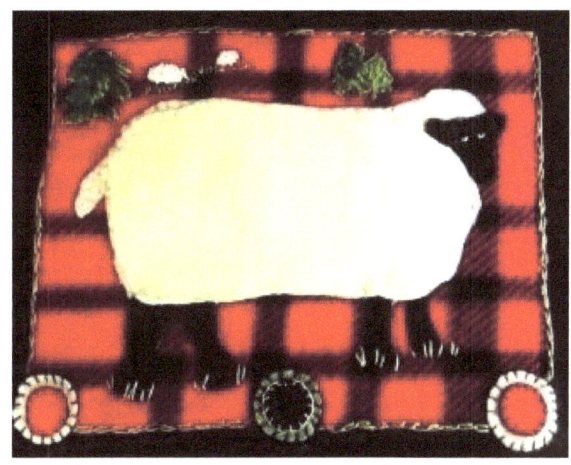

Mary had a little lamb its fleece was white as snow;

And everywhere that Mary went, the lamb was sure to go.

It followed her to school one day, which was against the rule;

It made the children laugh and play, to see a lamb at school.

And so, the teacher turned it out, but still it lingered near,

And waited patiently about till Mary did appear.

"Why does the lamb love Mary so?" the eager children cry;

"Why, Mary loves the lamb, you know" the teacher did reply.

The nursery rhyme was first published by the Boston publishing firm Marsh, Capen & Lyon, as an original poem by Sarah Josepha Hale on May 24, 1830, and was inspired by an actual incident.

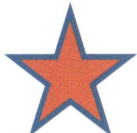 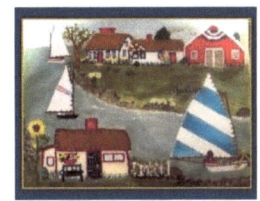 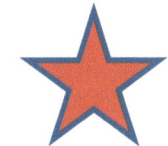

Welcome to my world

The fall sun is brightening and warming my new spacious studio/office in our new to us, old house in coastal Maine. I can glimpse through the pines and oaks a sparkle on the little cove at the bottom of the hill. Sometimes, I feel sure that I must be dreaming this amazing place where we landed (actually landed…after seven years of living aboard a 44' boat) as if having fallen through a wormhole, in space and time, to find ourselves in Brigadoon.

This is a real village, always has been, and if we the residents have our way, will always remain a tiny semi-independent enclave whose residents own the library, post office, Founders Hall (site of meetings, potluck suppers, holiday parties and weddings), the boat ramp, and village park. All of which is supported, cared for and preserved by the residents' participation in food sales, the Saturday morning gathering for coffee and home baked treats at the library, summer events open to the public, monthly suppers, etc. Like Alice, I have slipped into a rabbit hole and found the kind of life my over-active imagination has always dreamed of…and painted in my Americana Narrative Folk/Primitive paintings.

So it is that I begin this history of how I came to work with wool and what I have learned along the way that I hope will encourage and inspire you in your journey as you create wool folk art.

All three cats, Sarah, the mom and her daughter and son, Katy and Heathley are sprawled on the workbench basking in the warmth of the sun and their abiding love for one another. As it is with cats, what is yours is mine and my workbench is a favorite place.

I shall begin with where I am today, primarily creating Sailors Woolies, and move back through my history with wool, step by step, challenge by challenge.

I began with rug hooking. My mother hooked and braided many of rugs in the old house on Cape Cod where I grew up. She also made her own clothing patterns and sewed clothes for herself and my sisters and brother on her Singer treadle sewing machine, refusing to upgrade to an electric model.)I have always had a rewarding relationship with fabric. I made most of my daughter's dresses (she was a delightful child to dress, refusing to wear pants, when all the other little girls did.) Thus, fabric became an important part of my life.

My wise mother stored her wool with sprigs of rosemary and thyme from her copious herb garden. When I decided to try my hand at hooking, she gave me boxes and boxes of lovely wool to set me off on this new exciting journey.

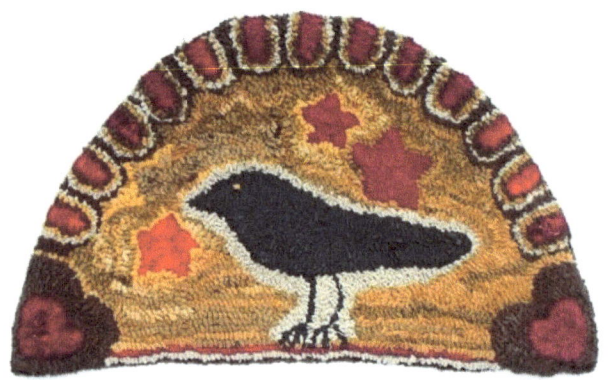

My love of folk art began early. I was born in Boston and transplanted to Cape Cod at age twelve to live in a rambling old sea captain's "mansion". These so-called mansions are the homes 18th and 19the century sea captains built for their families and to which they "visited", now and then, in between sea voyages that often lasted for years at a time. Because so many local sea captains chose the town of Brewster located on the inner elbow of the long sandy peninsula for its milder winters than other Cape Cod towns, it came to be called the Sea Captains Town. Mild being a relative term however, this town on Cape Cod Bay is protected from the wild Atlantic winds, nestled as it is into the sandy terrain hugged by nearby towns whose shores wrap around Brewster just enough to be favorable to these weather wise sea captains.

Cape Cod and nearby Nantucket Island produced hardy capable women who not only ran the family farms, but often governed the towns and villages in the Great Age of Sail. It fell to them to run the shops, post offices and other vital town functions when the men who sailed their great ships around the world were gone for extended periods of time. I like to think that I inherited that independence by osmosis from the spirits of those women all around me in those formative years.

My parents, who both attended art school and loved history, soon got involved with local artists and the Historical Commission of the town. We children were brought up to appreciate both art and history, particularly coastal New England history. My father taught me to mix paint colors when I was four. He bought me a sketchpad and a set of brushes and watercolors that seemed to me to be as powerful as magic. Thus began a lifelong obsession with color and form. A Grandma Moses painting in

a book caught my attention and the local librarian took up the cause by supplying me with stacks of books that ran the gamut from folk art to impressionism to cubism. However, I always came back to the "naïve" art of the early American limners. Itinerant unschooled (in art) painters who travelled the countryside trading a meal and a bed for their talent for capturing people, animals, architecture and scenery in a time when only the wealthy could afford such treasures for their walls. When my parents befriended the now renowned folk artists Ralph and Martha Cahoon and my mother went to work for Peter Hunt, all of whom were just beginning to make a mark for themselves in the folk art world, the real magic took hold of my young life. The Cahoons are well- known for their whimsical mermaid paintings and Peter Hunt for his wonderful painted furniture reminiscent of European and Pennsylvania Dutch folk art. These kind and generous artists taught me and mentored my burgeoning love of painting in the folk art tradition. All these years later, their spirits are still with me, have traveled with me on my long and wonderful journey as a folk artist. Because of them, I have enjoyed many years as an Americana Folk/Primitive artist showing my work in prestigious galleries from coast to coast as well as in England and Japan. I think they would be proud of my success, and pleased that my work is in private and public collections worldwide.

Homage to Ralph and Martha Cahoon & Peter Hunt

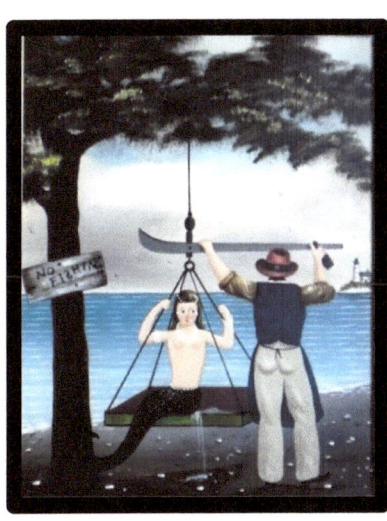
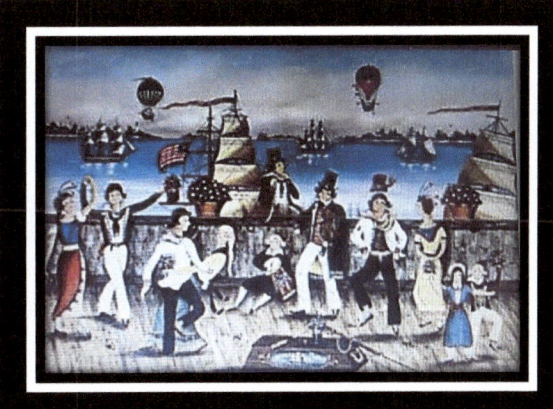
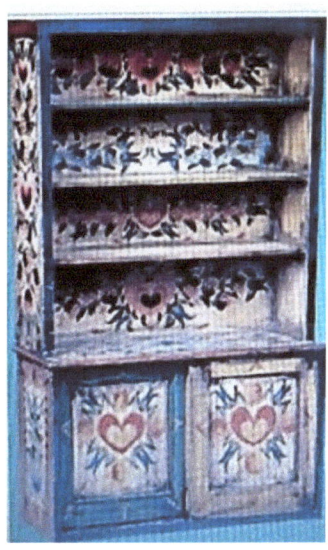

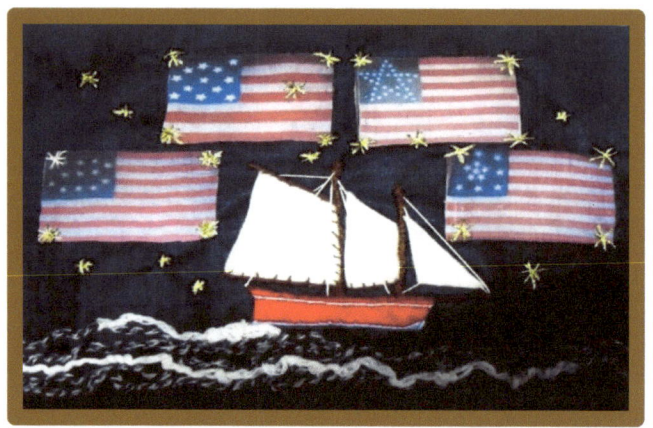

 A visit to a London gallery, when I studying in that magnificent city of magnificent art galleries, brought me face to face with Sailors Woolies. This momentous collision with a new folk art form that immediately appealed to my deeply embedded love of both history and the sea changed my life as an artist. However, that change did not manifest itself in my art career until a number of years after that first introduction. As it happened, I had to set aside my desire to jump into creating what I began thinking of as Americana Sailors Woolies because my folk art canvas painting career suddenly took off. Americana Sailors Woolies would have to wait.

 Left to gestate in the recesses of my mind, Sailors Woolies grew like a well-fed garden until the time was right for the harvest. Yes, ships and whales and the sea would always take precedence however, I would expand my work to include all the things I love about New England primitives. I could visualize village scenes, Colonial architecture, the austere simplicity of Shaker arts, the wonderful historic houses of Nantucket, and the lure of traditional Cape Cod houses. And, of course, mermaids!

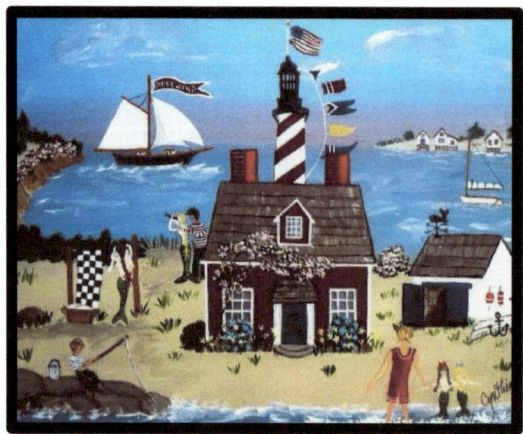

Introduction to British Sailors Woolies

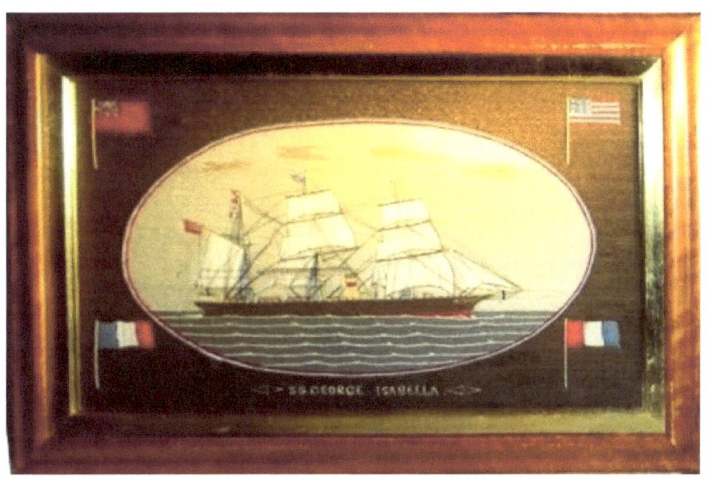

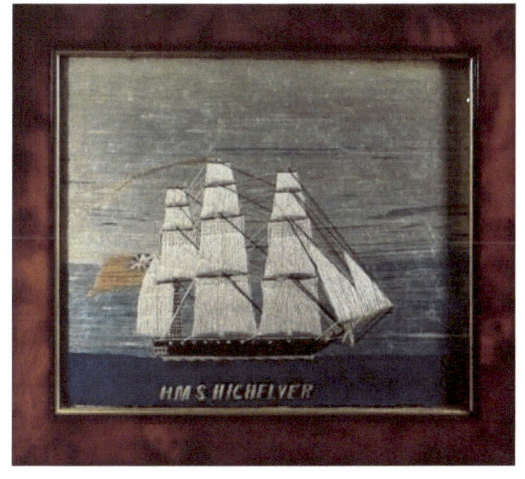
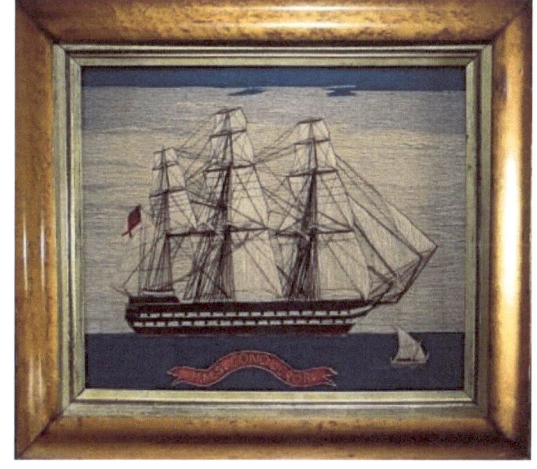

History of British Sailors Woolies

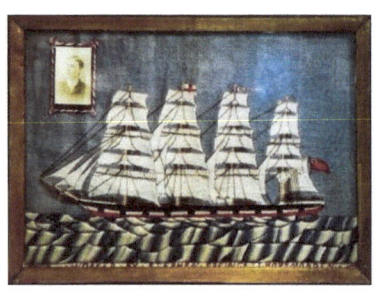

Woolies were created by a British sailor, sometime between 1830 and 1880. All great creative ideas have a single point of beginning, a moment of inspiration, a need to bring forth something new from something that already exists. That is how Sailors Woolies began. No one knows how the idea spread, but thankfully, other bored sailors soon turned their hand to creating "woolies" as they came to be known.

Try to imagine a lonely and bored sailor with little to challenge his creative nature during the long, often tedious, and seemingly endless hours, weeks, months and sometimes years at sea. In between whale sightings, battles, storms, and brief landfalls there was damned little to do on a ship back then. Once the decks were scrubbed, the brass polished, the lines inspected, etc. finally sailors had some downtime…and one had a grand idea that changed the history of folk art.

Bored silly with playing cards and telling risqué jokes, one day the young sailor happened to go looking for some mending thread in the sewing basket sent aboard by someone's thoughtful mother, sister or wife…perhaps the captain's wife…and the rest is art history.

It was the habit of his shipmates to toss torn and worn out torn clothing into an old crate below decks, where the mending basket resided, purposely ignored until there was nothing fit left to wear.

Perhaps, this sailor, as he searched for the tools to repair his torn woolen pants, was awestruck by an amazing idea. He liked to use his hands, he'd tried sketching as a boy, he'd watched the women sew and mend. Thus, desperately needing something creative to do to assuage his deep boredom, he birthed a new folk art. What he knew were ships, whales, and distant views of land, so this is what he pieced and stitched. Very likely, the boy was laughed at and called a "sissy" for doing "women's work." No matter, finally, he was no longer bored. Serious artists know that when the creative muse arrives, although the desired materials may not be available, *a way will be found*.

Excerpt from Antiques and Fine Art Magazine
Stitches of History: Art of the British Sailor
Katherine E. Manly

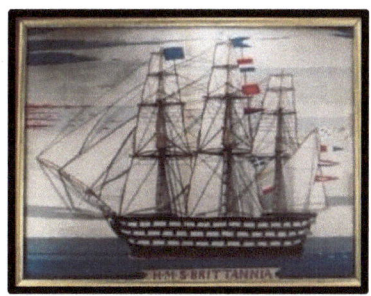

There is little contemporary literature referring to Woolies. Therefore, much of what is known is based on hypothetical supposition. Most of the vessels depicted fly British flags. Based on this evidence, historians believe that British sailors executed nearly all known wool works. Frequently, ships will fly both the British flag and that of the nation in which the ship is visiting, but some Woolies show only a foreign flag. In this case, one is unable to ascertain whether this is the indication of a foreign hand or simply a view reproduced by a British one.

Steven Banks hypothesizes that their inspiration came from the Chinese embroideries sold to sailors in Hong Kong and the Treaty Ports, which opened to the West in 1842. The height of the craze for wool pictures in the third quarter of the 19th century corroborates this theory.

The enchantment of Woolies is that they are folk art. They were made by the hands of men who were not formally trained in embroidery. Regardless, it is understandable how such tough men could create such delicate pictures. Woolies are the creative product of sailors' spare time, excess materials and a basic, yet necessary, familiarity with needle and thread. Until the mid-1880s the average seaman had no standard uniform. Not only did he sew his own clothes, but also one of his duties was to maintain the ship's sails. Furthermore, sailors used embroidery to individualize and embellish their garments, frequently in eccentric designs. Therefore, spare time between watches combined with basic sewing skills and imagination became the rich soil from which the art of Woolies grew.

Most of the materials used to make Woolies were found on board ship. Sail canvas, duck cloth from sailors' trousers or a simple linen or cotton fabric was used as a base. The stretcher commonly was made from excess wood with simple tenon joints, without wedges. Only the Berlin wool, cotton or silk would need to be brought from home or acquired in a foreign port. Sailors mainly chose to use vivacious colors—chiefly white, blue, red, brown and varying shades of green. Early Woolies are made of naturally dyed wool. After the development of chemical dyes in the mid-1850s, sailors could obtain a greater range of colors at a less expensive price. *End*

Sailors Woolies
Close Cousins:
Samplers

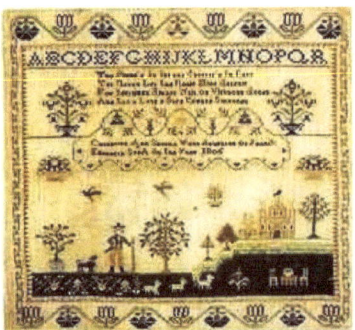 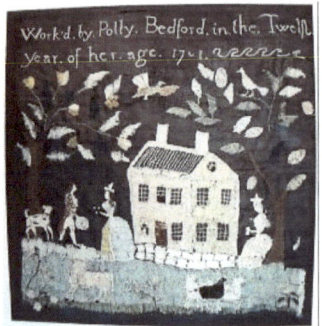

Long ago, girls learned to sew, mend, spin, and weave. To practice their stitches, young girls made Samplers. The sailors who made Sailors Woolies learned by a kind of osmosis; from being around the quintessential needlework art rather than by doing it. The relationship between Sailors Woolies and Samplers is evident. Although Samplers were exclusively stitchery, we can see how applique combined with needlework detailing was an offshoot of this art form that improved young girls' needlework skills. That said, there are a number of wonderful woolies that were created with nothing but thread work.

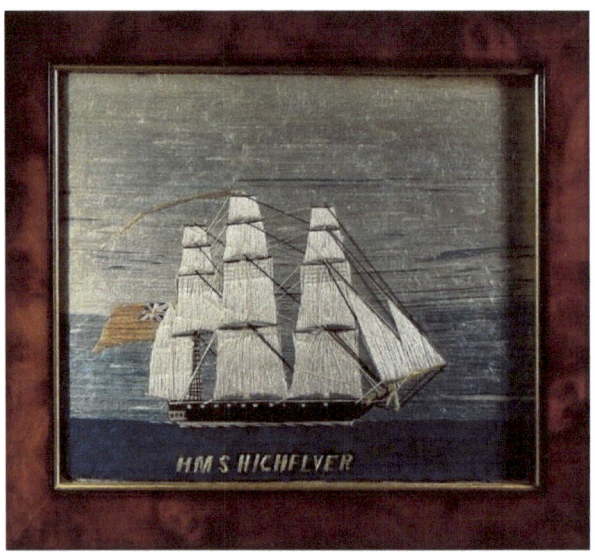

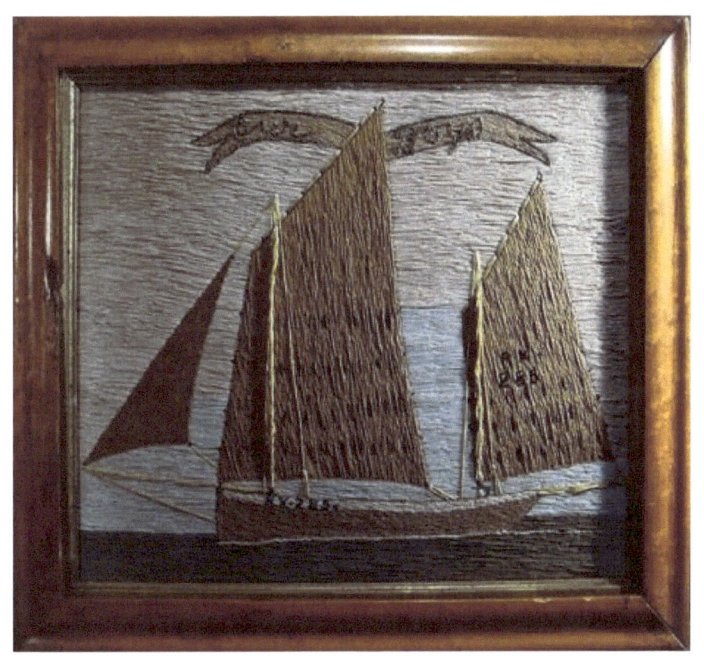

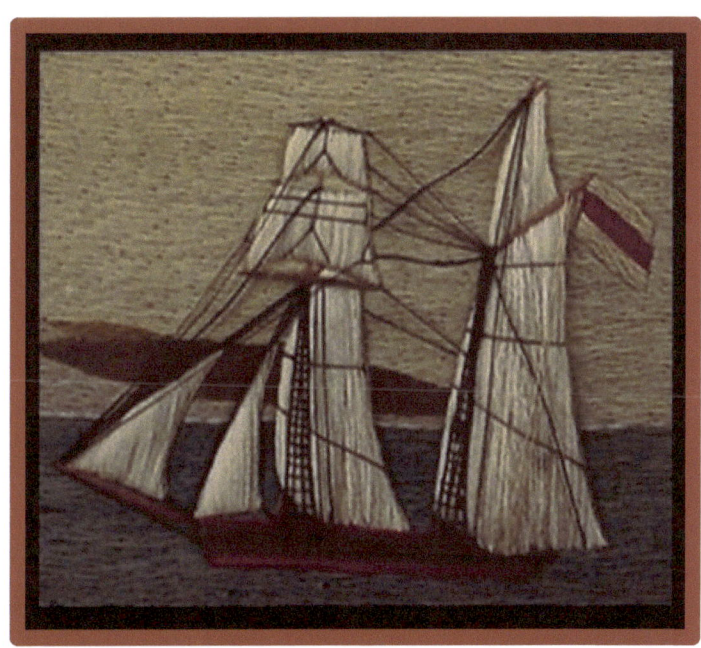

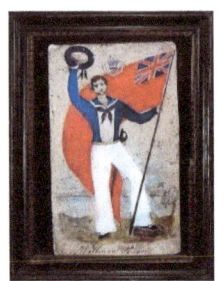

Sailors ought never to go to church. They ought to go to hell, where it is much more comfortable.
H. G. Wells

The majority of British Sailors Woolies are portraits of ships, either sailing ships or ships that combined sail and steam power. Most ships were depicted with all sails set and full however, I love the ships with bare rigging festooned with colorful maritime signal flags. Some of these sailor artists employed a quilting technique called trapunto (padding) to give the sails the look of being full of wind. Indeed, this was a very complex form of folk art and, most certainly, a very demanding task aboard a rolling ship.

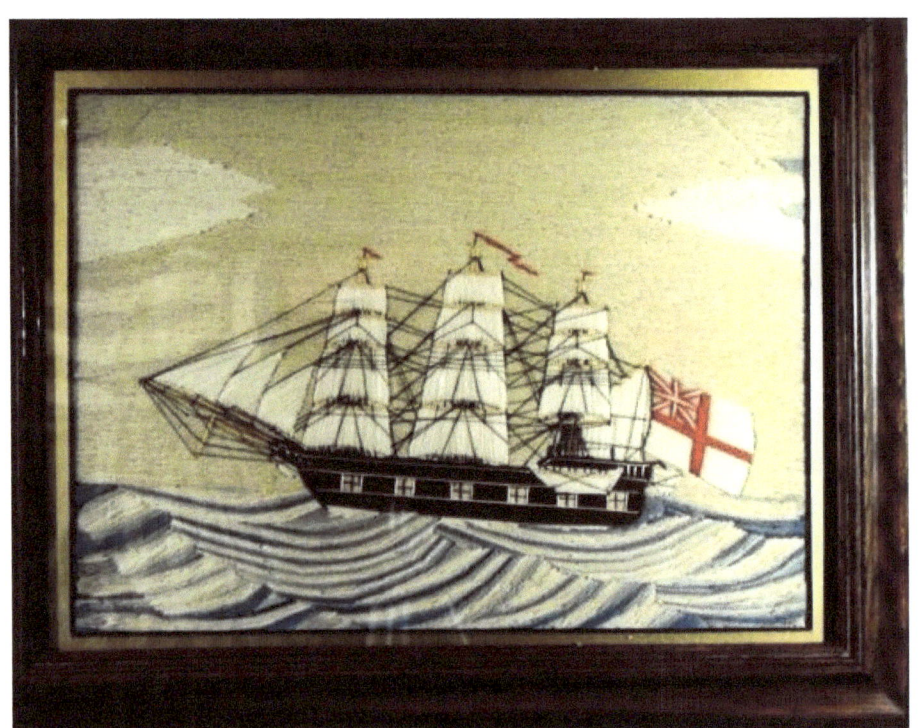

Ho, ho, ho, it's a sailor's life for me

Art Scholars and collectors are still learning about Sailors' Woolies because they are rare and difficult to find in good shape. Sad to say, they are an ephemeral form of art. Moths, weather, and general wear has ruined many Woolies. Like paper and other ephemera that can easily be lost to history because of its evanescent nature, this art form suffered greatly down through the years. Some Woolies were signed however, most were not. With no cameras to record sailors' experiences and what they saw for loved ones back home, a handful of talented sailors did manage to record the beauty of ships at sea, foreign ports, sea battles, and the raw beauty of the nautical lifestyle in needlework. Born out of tedium, a new genre of folk art evolved. Today this unique art is extremely valuable and costly to collect because of its rarity. Very few original pieces show up on the art market. The number of original British Sailors Woolies is finite therefore, when they are all in private and public collections, there will be no more available.

This is where I come into the picture. I have dedicated myself to reviving and re-birthing this unique, and "most rare of the folk arts." In addition, I have endeavored to spread the history of the British originals while revising the art to include historic New England "stories" told from the perspective off someone who knows and loves the northeastern edge of the U. S. continent,

 Being a sailor myself, I like to believe that it took a sailor to revive Sailors Woolies.

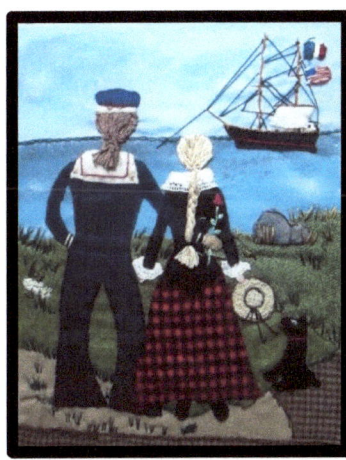

British Sailors Woolies
Meet
Americana Sailors Woolies

In 2005, leafing through years of art notes and photographs, as my husband and I made ready to sell our house on Cape Cod and store our possessions in preparation for moving to live full-time aboard a 44' trawler/yacht, I came across my copious notes on British Sailors Woolies. Suddenly, it was time.

Unfortunately, this was a very impractical idea! There was no way I could make room aboard for all the wool, thread, frames, etc. I would need to create woolies. I had a huge supply of over-dyed wool from hooking rugs and dyeing my wool to get the wonderful antique colors I loved. The muse was calling…but at the worst possible time. Facing a major conundrum, suddenly, out of the blue, and against all odds and likelihoods, the impossible became possible; not only possible, but also advantageous, on a number of levels.

We had made the decision to sell our beloved home and most of our possessions to follow a long held dream of being boat gypsies. Such a life altering metamorphosis does not happen overnight. We had been considering living aboard a boat for some time. Always sailors, happiest when on the water, yet loving our home and land-bound pursuits, still we knew that it was "now or never." There is a time in mid-life, when you see before you a portal, a beckoning doorway that challenges everything you have long held as solid and permanent. Some ignore the door while others plunge on through: not without trepidations, not without certain anxieties, but ready for a new life adventure, willing to take a chance.

In the space of time between finding a buyer for our house and the final steps that would leave us homeless, I decided to try my hand at creating a Sailors Woolie to pass the time. One woolie led to two, and two to seven that I took to show the gallery owner on Nantucket where my canvas paintings were doing very well. She loved them and immediately began planning a show for my new work. It was as obvious to her as it was to me that this work was a natural for Nantucket.

We had always entertained a dream of living on Nantucket Island. We had been sailing there for years, had spent a number of Christmases at the lovely Jared Coffin House Inn, and, after all, it was where my other work, on canvas, had found a lucrative "home". My plan had been to put my painting career on hold until we found a warm tropical port where we would put down our anchor for an extended period. In the meantime, I planned to write fiction as my creative outlet. The best laid plans…

Americana Sailors Woolies made their first appearance at European Traditions Gallery on Straight Wharf, Nantucket, in the fall of 2005. They virtually *flew* out of the gallery, and soon Chicago, California, and New York came calling for my new work. When the National Art Gallery in Tokyo purchased two pieces for its permanent international folk art collection and a small gallery in an art lovers' village in England asked for six pieces, it was obvious that Americana Sailors Woolies had been codified as a new folk art form.

We made the necessary arrangements to spend the winter tied into a slip in Nantucket Harbor. We would still be liveaboards, but with the wonderful opportunity to live on Nantucket Island with its superior library, great restaurants, shops and grocery store all within easy walking distance to the town wharf. Our boat had a newly installed cutting-edge heating system, thus, we were ready for a cozy winter. Our very first winter as full-time liveaboards coincided with the beginning of a new creative outlet for me that has, to this day, fully captivated me as a wool artist.

For the next five years, as we lived aboard our boat, cruising the east coast, eventually putting down temporary, but extended roots in Puerto Rico, I continued to work on both Sailors Woolies and fiction writing. I did some canvas painting, but with a new influence from some other sailors.

Eventually, Americana Sailors Woolies and Mermaids Valentines met, and the relationship seemed to have been meant to be!

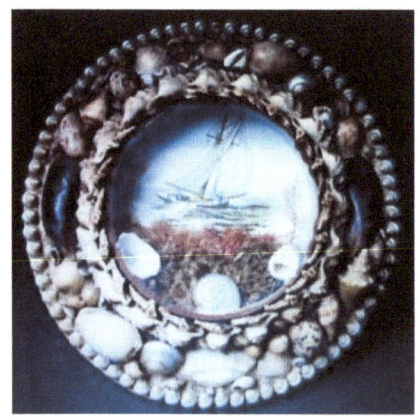

　　Believed to have been inspired by the intricate shell work done by women on Barbados in the 1800's, for sale to visitors as souvenirs, **Nantucket Sailors Valentines** are another example of wonderful art that resulted from tedium and boredom aboard ship. As Nantucket sailors sailed the world, particularly in the Pacific, hunting whales, their fascination with the huge variety of exotic seashells inspired a new sailors' art form. Just as British sailors did, Nantucket boys and men mitigated tedium by creating art from what they had at hand.

　　This then is the story of how two sailors' folk arts met and merged. Ships and the sea, mermaids, whales, and seashells…and threading through these paintings are the stories that every form of folk art tells. Remember to read a folk art painting whenever you have the opportunity. History in pictures.

　　A definition of sailing:　**Hours and hours of tedium interspersed with moments of stark terror.**

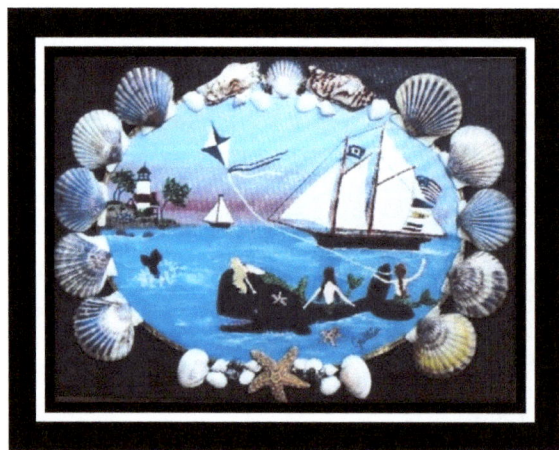

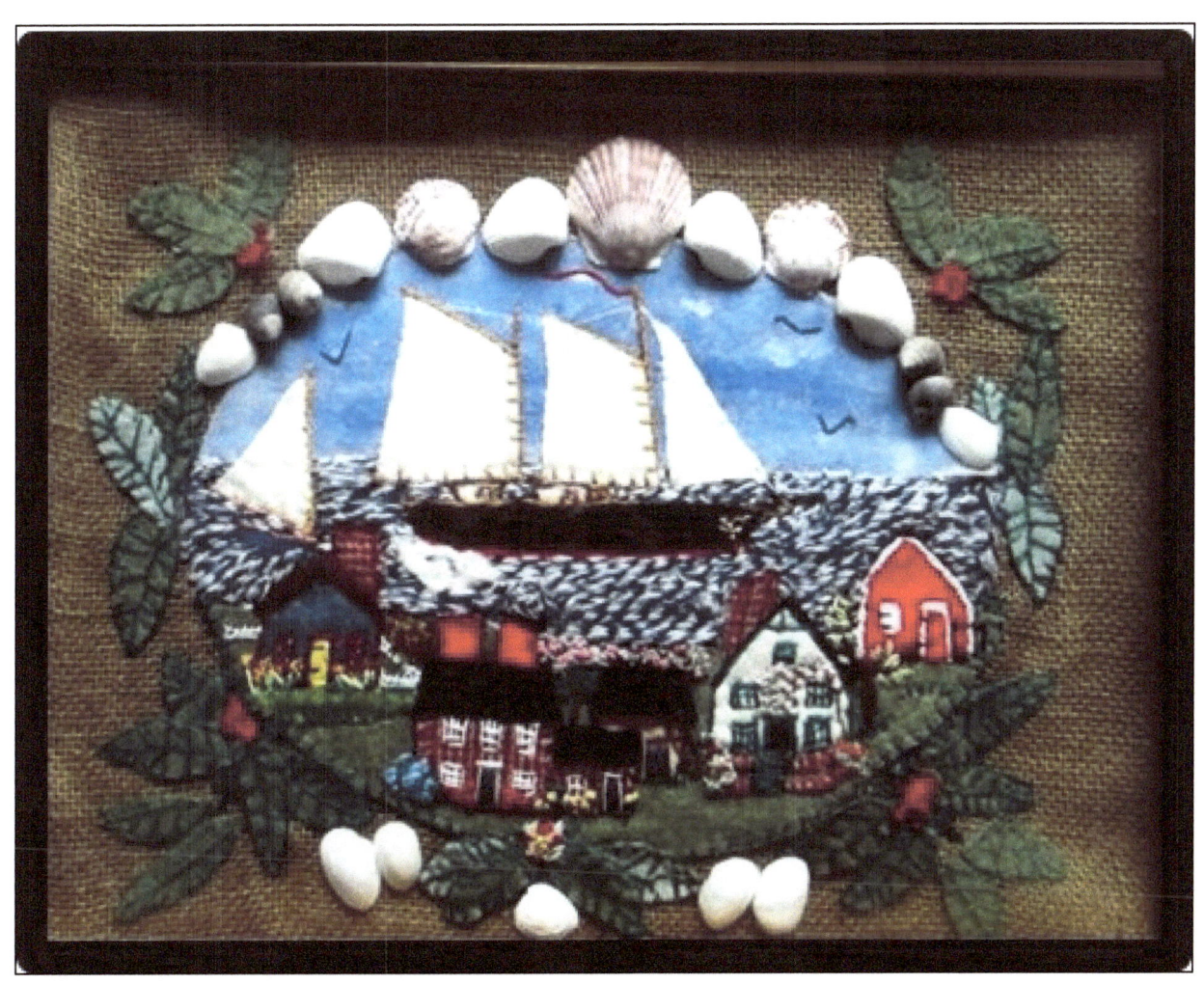

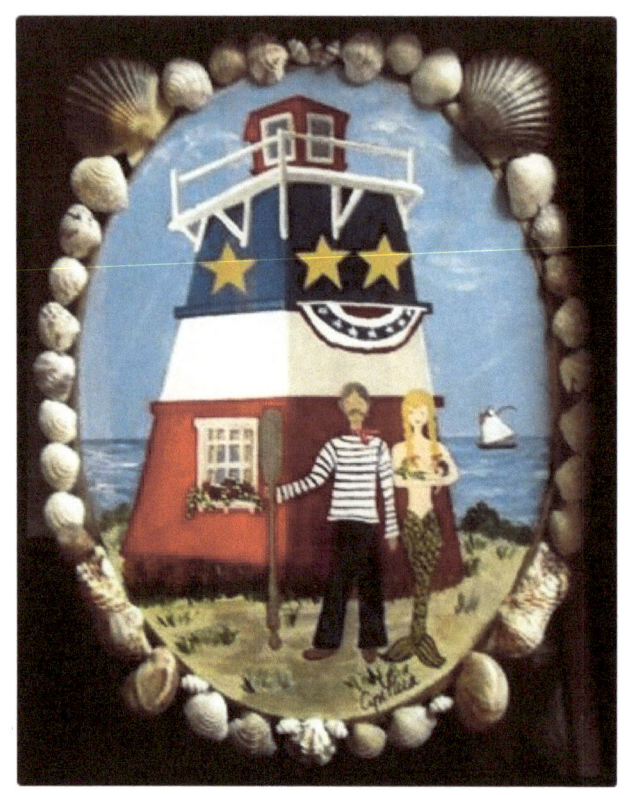
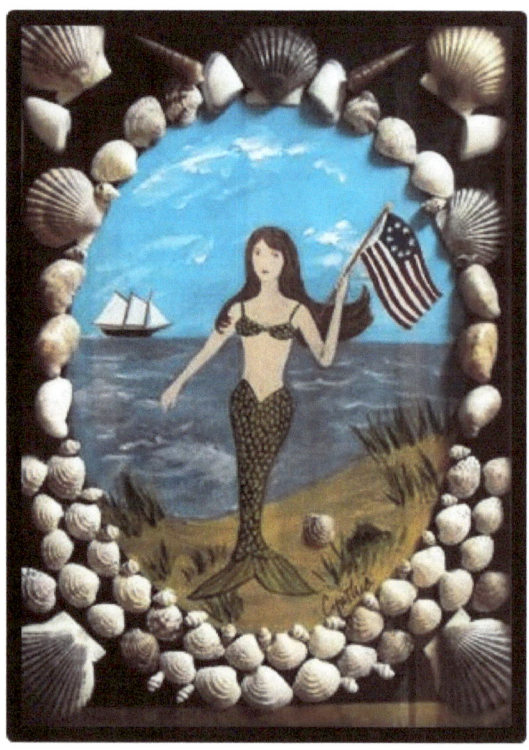

Americana Sailors Woolies

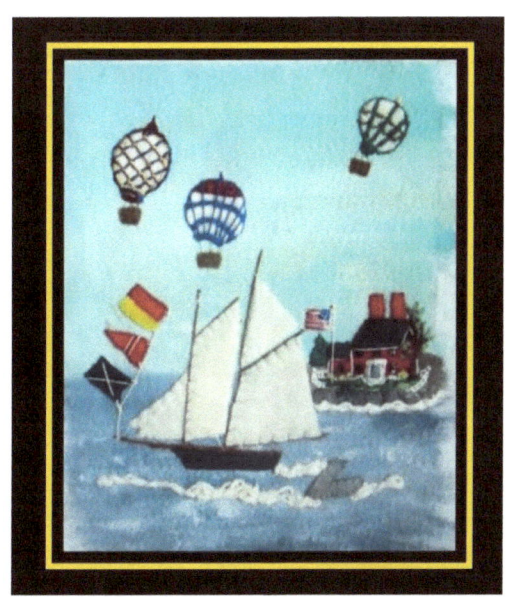

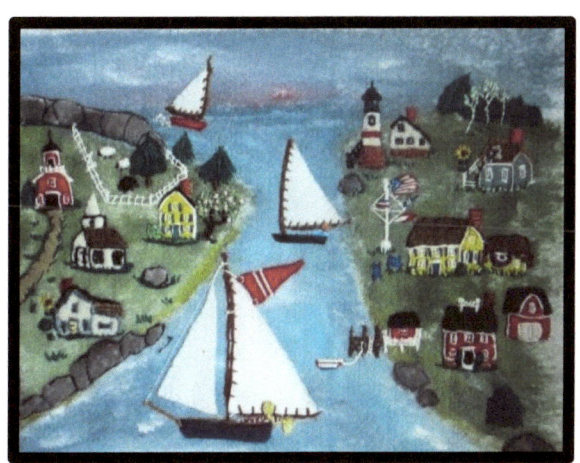

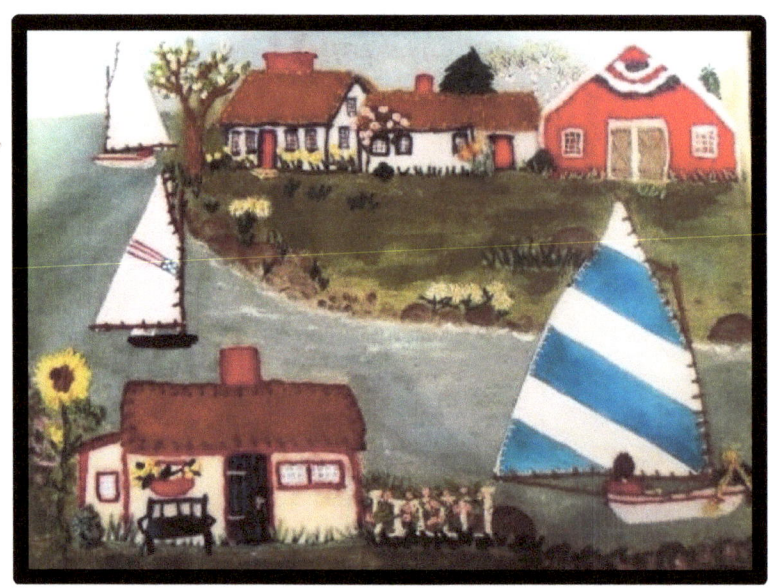
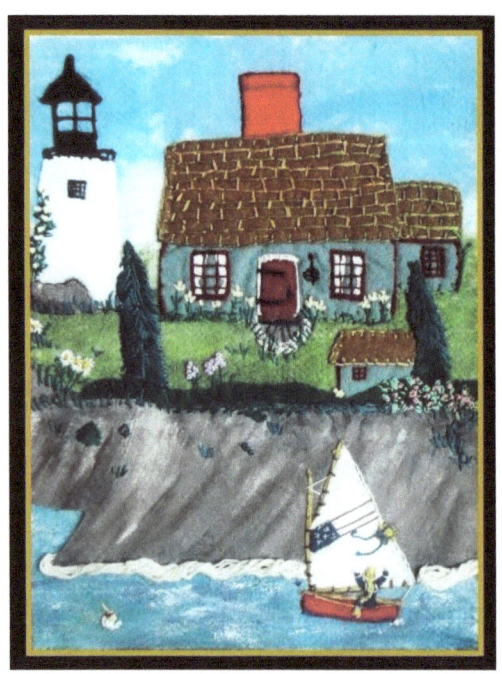
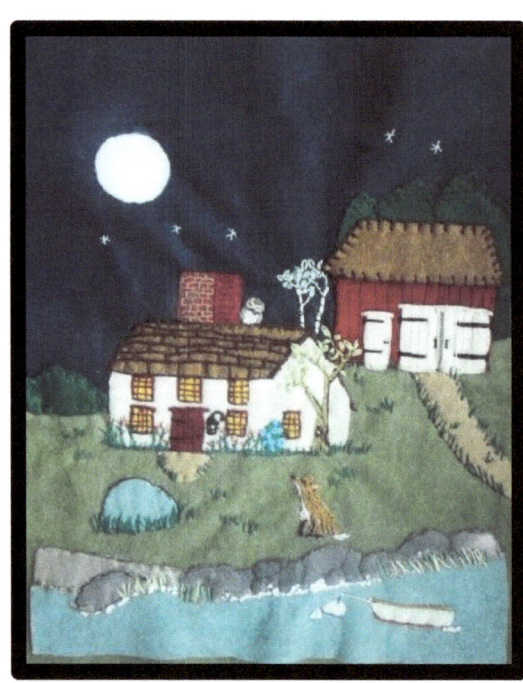

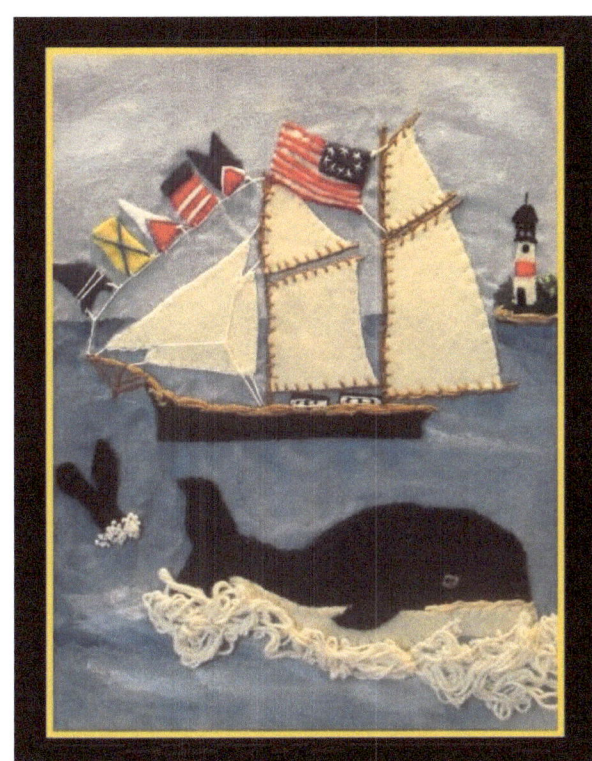
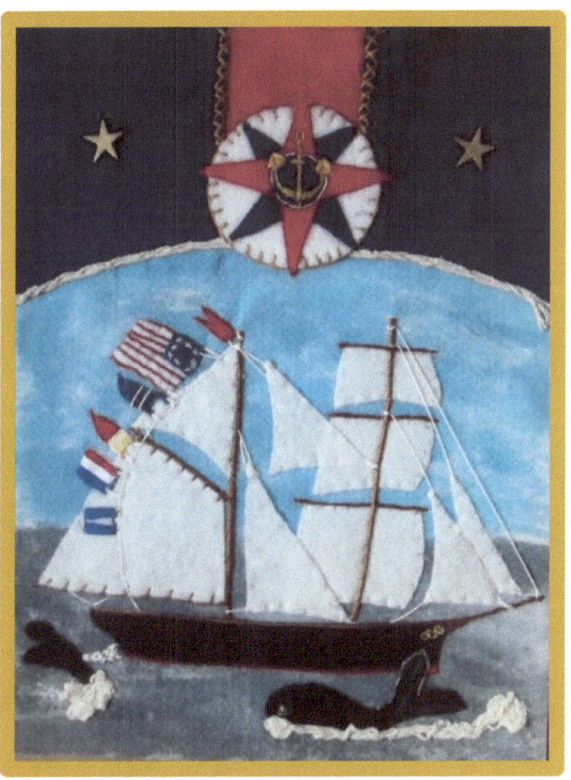

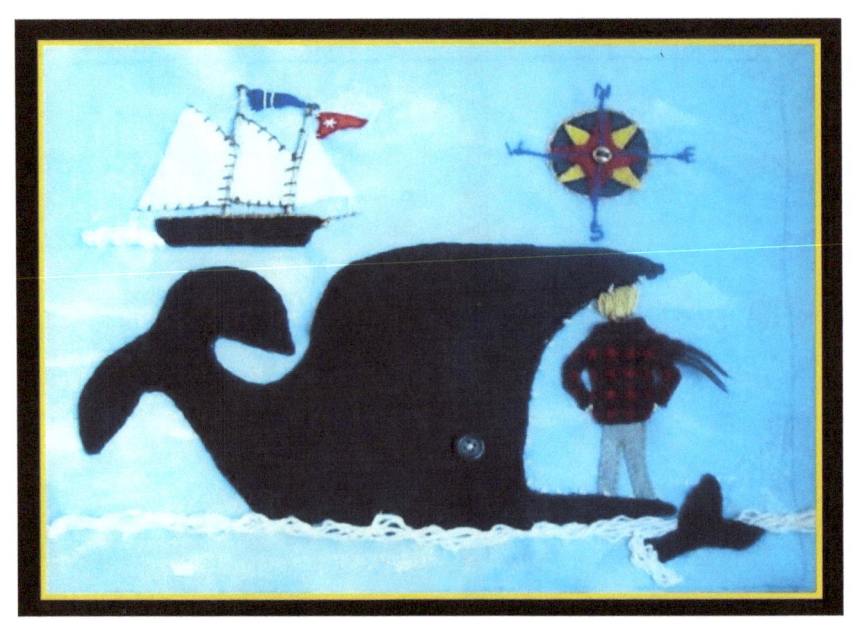

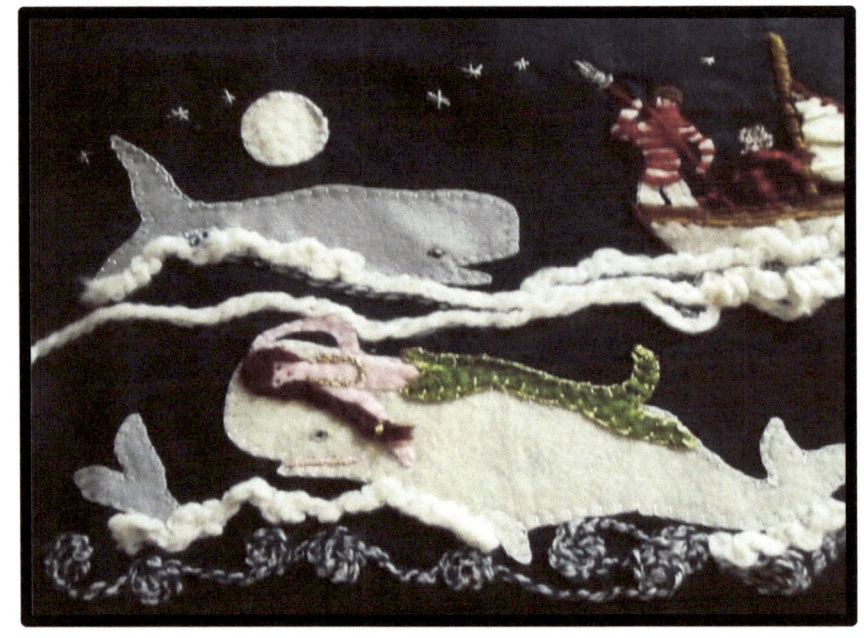

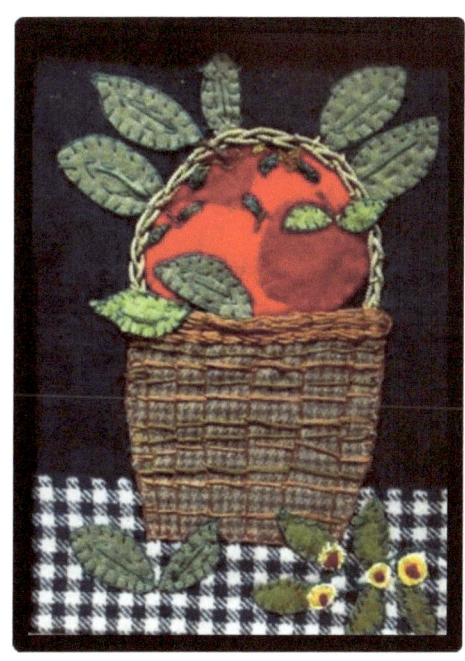

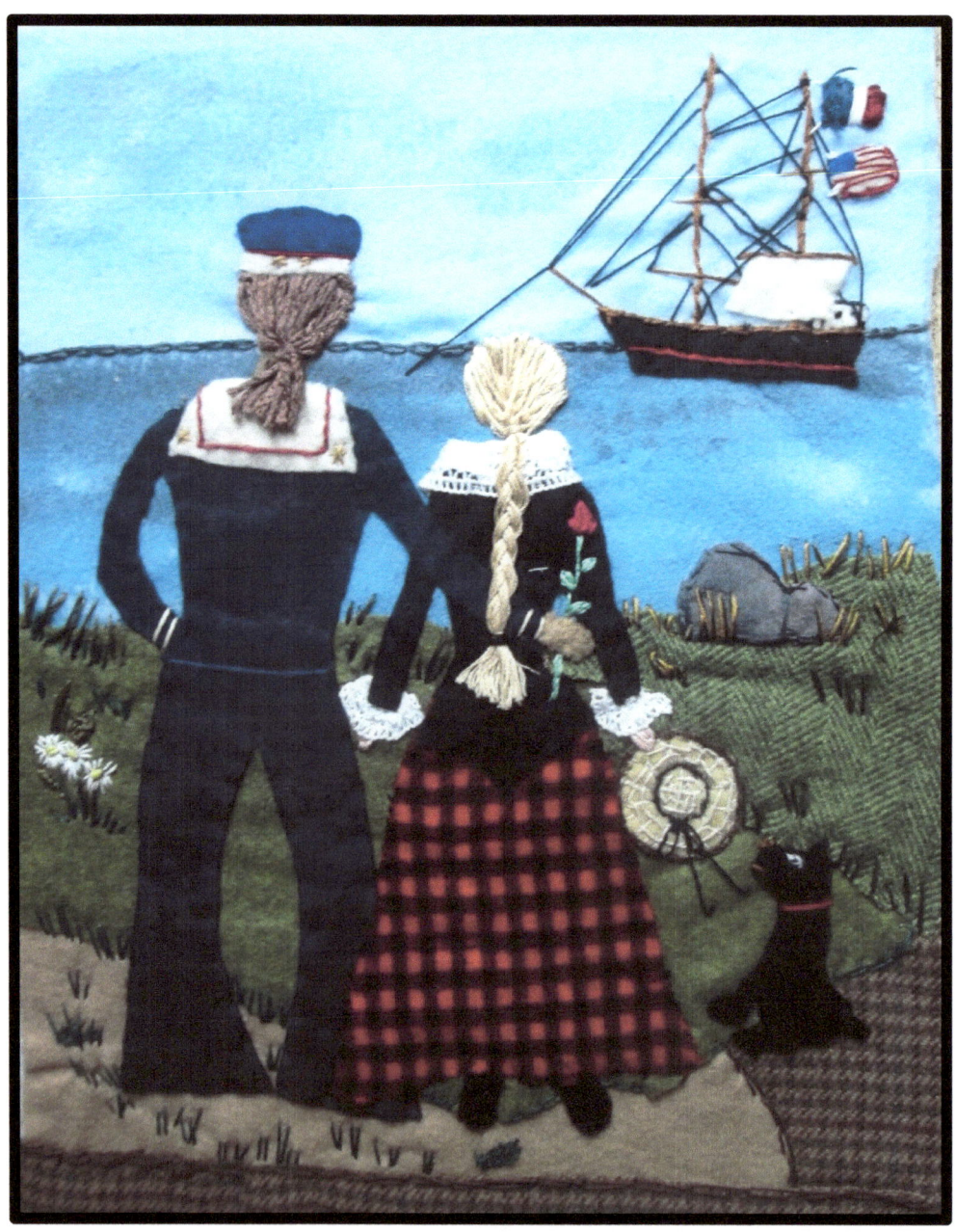

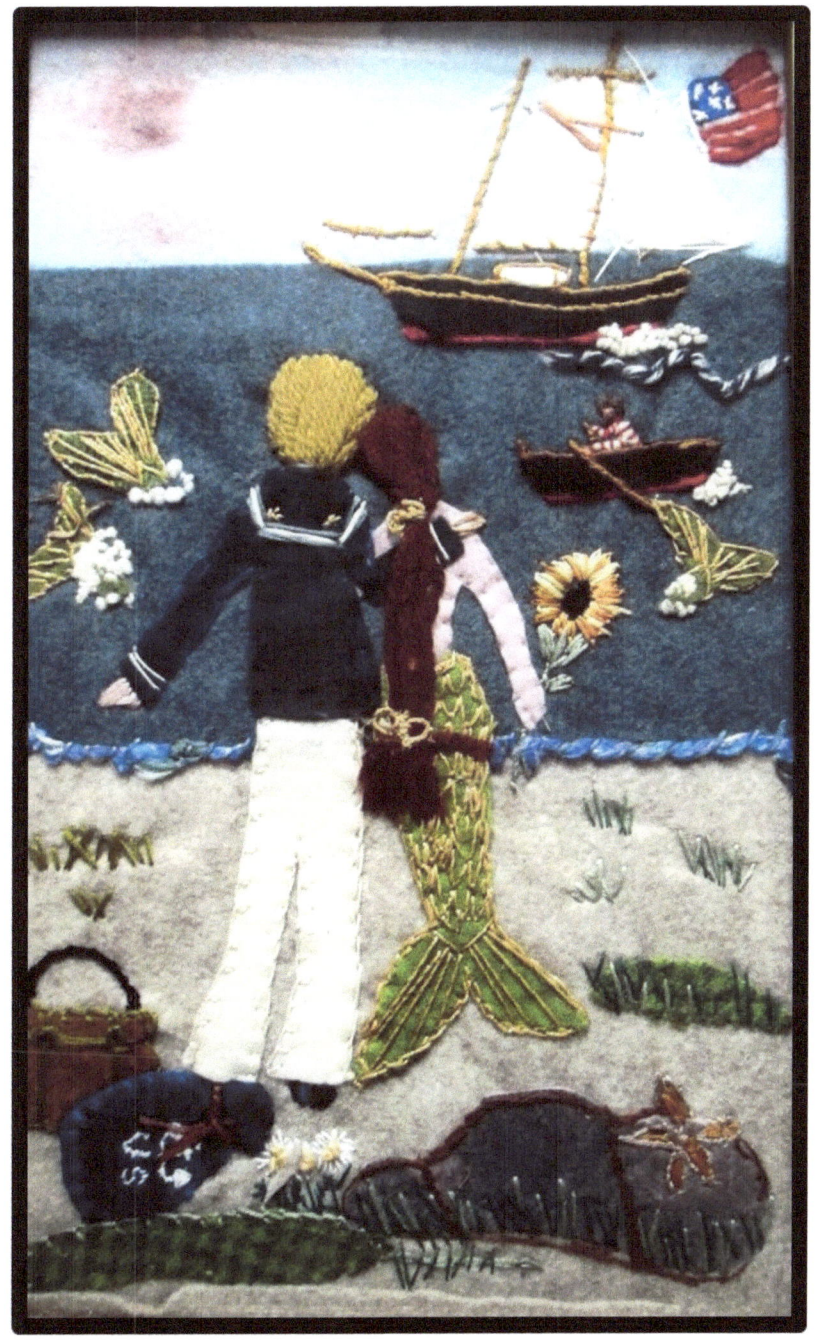

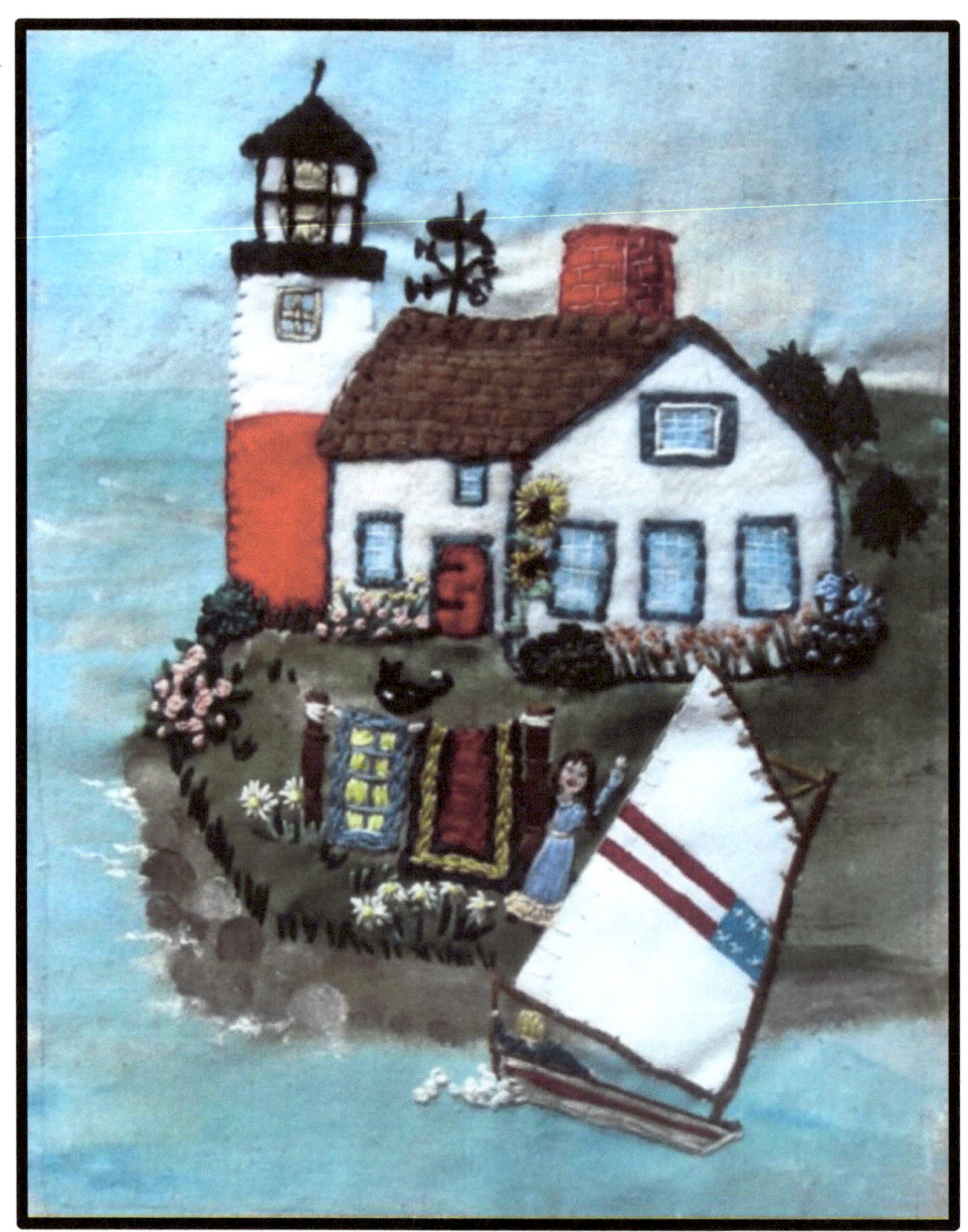

Inspiration Can Come From Anywhere, Any Medium, or Daily Life.

I found this wonderful wooden Jonah and the Whale Folk Art sculpture on-line. Had to do a Jonah! By the way, at this point I feel I must aplogize for my photography. I am a painter, not photographer and, in addition, a self-publisher who does not have a wonderful staff of professionals saving my neck. Thanks for your forbearance.

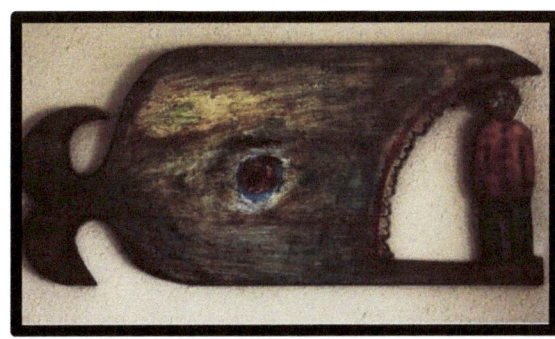

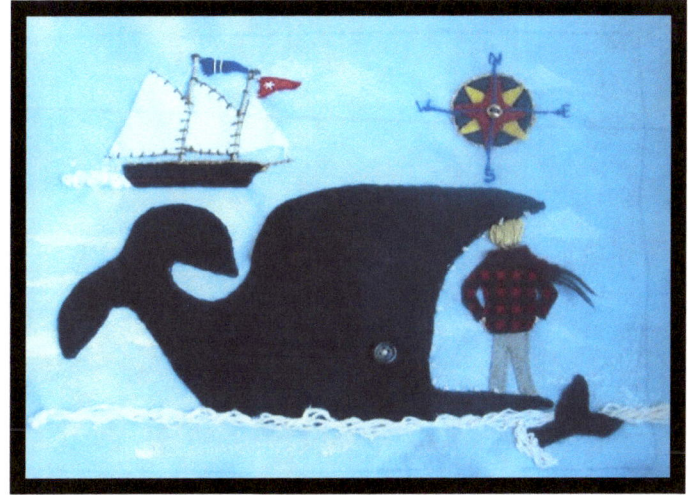

Woolie version: **Jonah of Maine**

P.S. Jonah sold within hours of being hung at Ironbound Gallery, Camden, Maine.
Time to create another. Although I often repeat designs, they are never ever the same. They are spin-offs with each their own unique character. I am a dedicated one-of-a-kind artist

A stitch in time...a grand tradtion

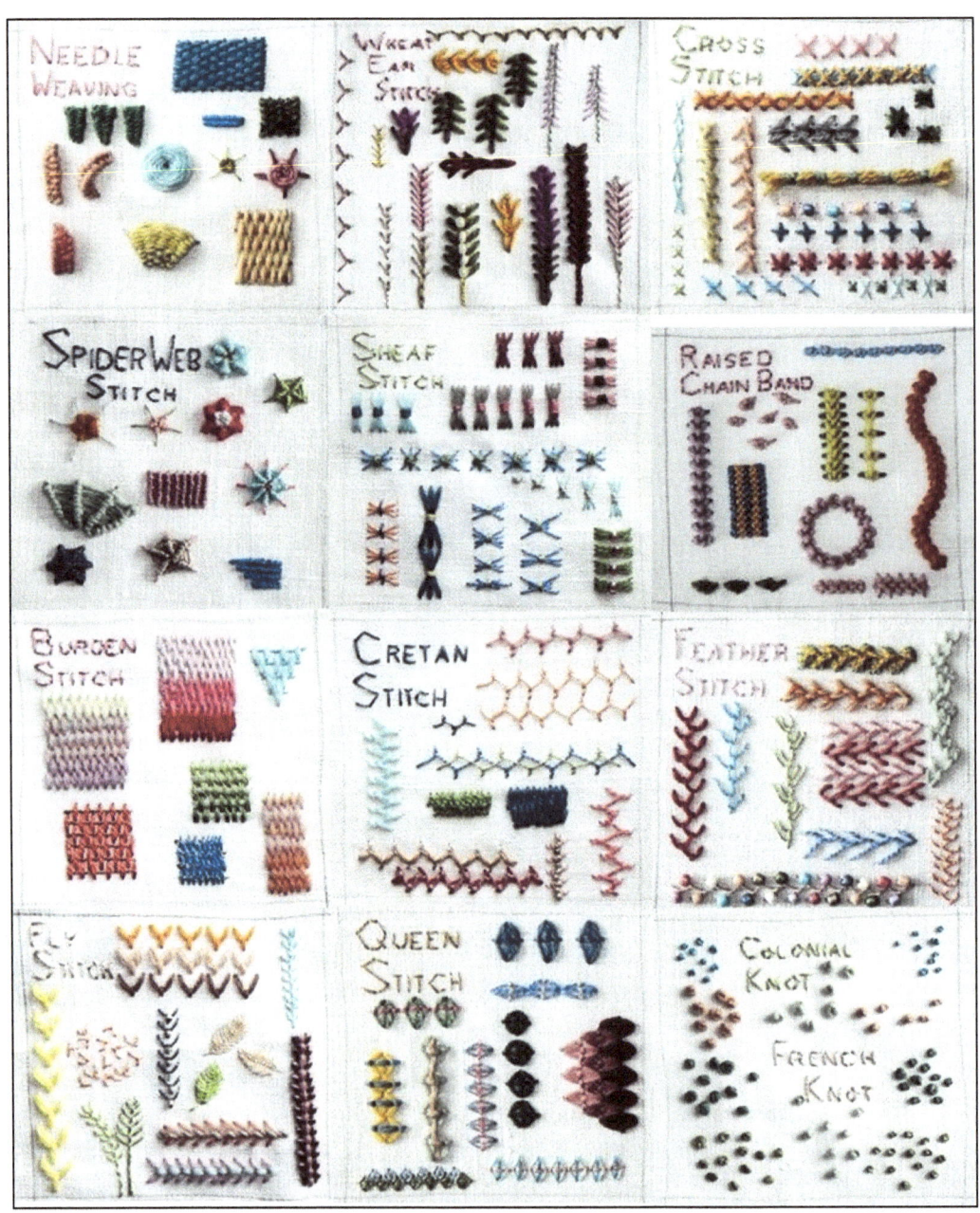

How to Make a Woolie

One of the wonderful advantages to artists today is the ease of internet research. When I want a vintage ship or other vintage graphics I have figured out that if the site does not have a way of allowing me to copy the print (make sure you are not taking something protected by copyright, however there are many sites that have graphics that are copyright and royalty free) I can photograph the picture.

My little digital camera takes good photos that I can then put into my computer for printing to make templates. Make a print for your permanent file and one to be your guide for the fine details when sewing your Woolie. Then, make a print on cardstock to cut up for tracing around the shapes.

Naturally, some of the Woolies I create are strictly out of my imagination or bits and pieces of other work I have done. Sometimes, I recreate a canvas painting as a Woolie or hooked rug. A bit of research into vintage graphics, vintage folk art, and vintage art is always helpful.

Here is a lovely vintage schooner that I will be using for both a Sailors Woolie and a Hooked Rug for my son and soon to be new daughter-in-law.

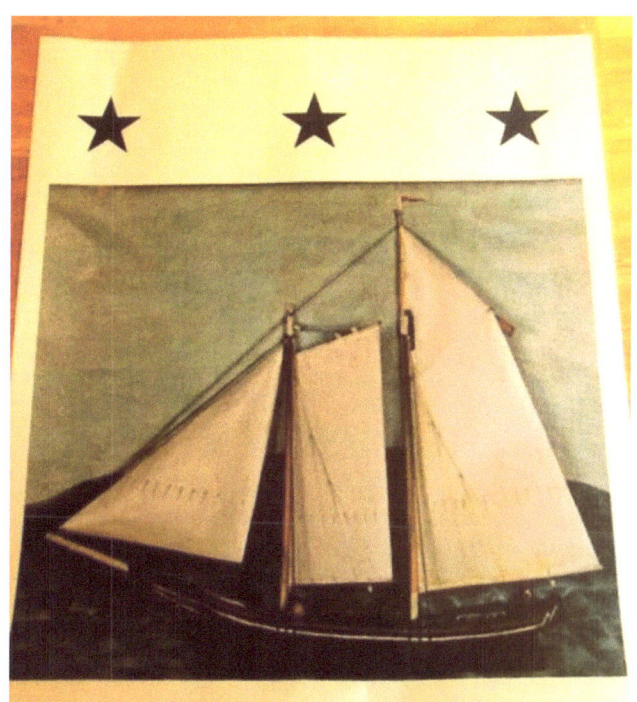

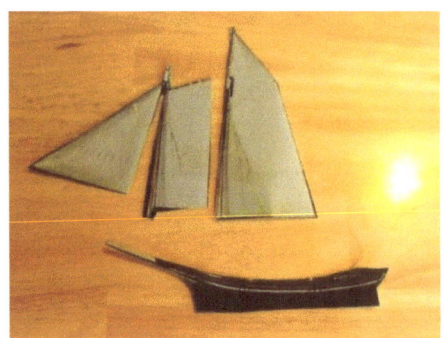

 Here it is, cut into the principal template pieces I will need to cut the wool. Pattern making is easy this way. However, *always* make sure you have a print of the original so that you have the detail you will need for the final work once you have cut up the cardstock image. In addition this will go into your permanent file along with the pattern pieces (plastic food storage bags are perfect for storage and protection.) I often use pieces of former projects to form a new painting. Mix and combine those things you love best. The ideas that come up from leafing through your files can delight and amaze. My father learned to call these files Ghost Files, when he was in art school. I'm not sure why, but I still use the term in his honor.

 Choose and cut background wool or felt to size. Knowing the standard sizes of frames available from suppliers will help you to decide sizes. Do not hesitate however to use a great old frame found at a thrift shop or antique shop that is not a standard size. Simple frames are best for folk art. An overly decorative frame can overpower the simple primitive charm of your art.

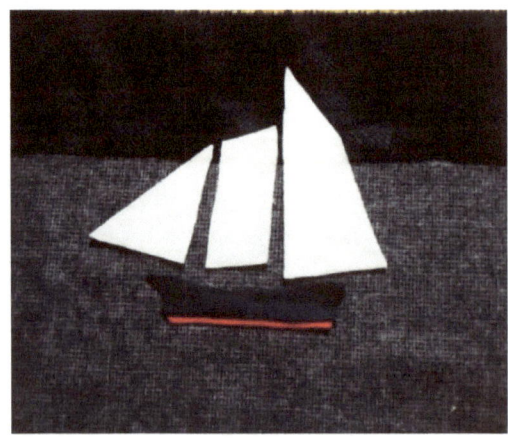

When the pieces of ship are secured to the background by iron on adhesive—I use Stitch Witchery, it is time to begin stitching. Remember to leave the deck of the ship free for tucking in the yarn for the masts. Mahogany colored bulky cotton yarn for the masts and bowsprit. Because this yarn consists of multiple strands, it creates a nice rounded effect when applied with capture stitches. Tuck the bottoms of masts and the bowsprit well under the edge of the deck and bow to secure. Capture the yarn that wants to unravel by securing immediately with embroidery thread using capture stitch aka wrap-around stitch in a complementary color. Sometimes, I use a hoop, sometimes not. Be aware of not pulling stitches so tight they cause excessive puckering of the wool when not using a hoop. However, slight puckering will disappear when steam pressed.

A word about needles. You will need to purchase packages of assorted embroidery needles with a variety of eye sizes and good points that will go through multiple layers. The quality of the work is dependent on the quality of the tools. Purchase an excellent pair of fabric scissors.

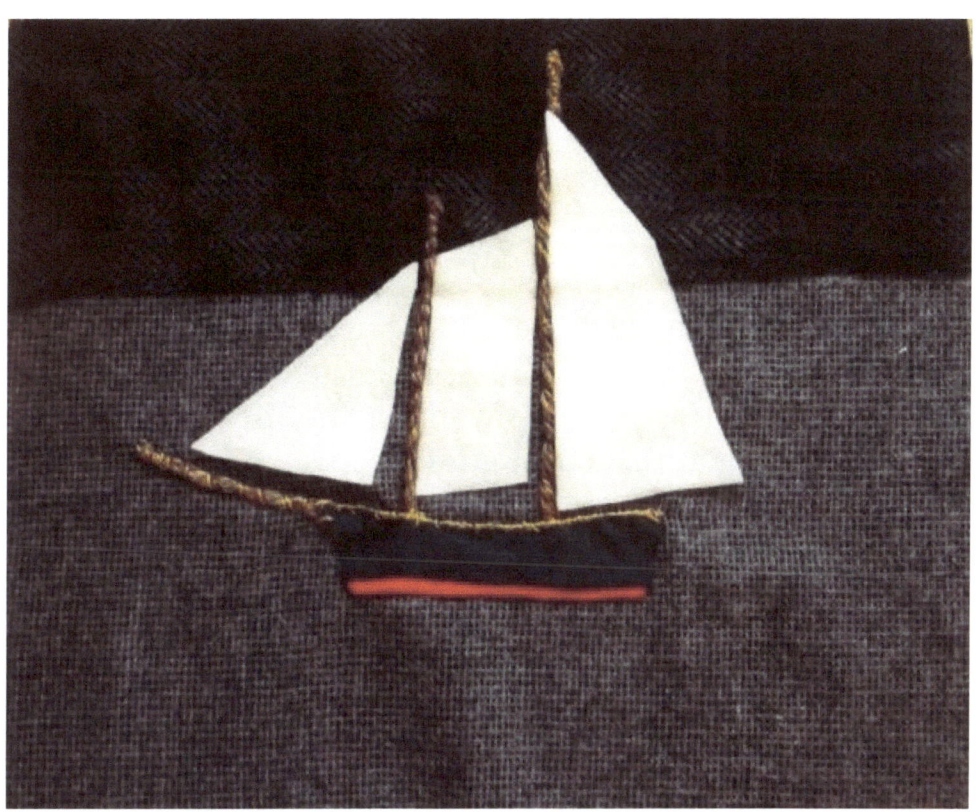

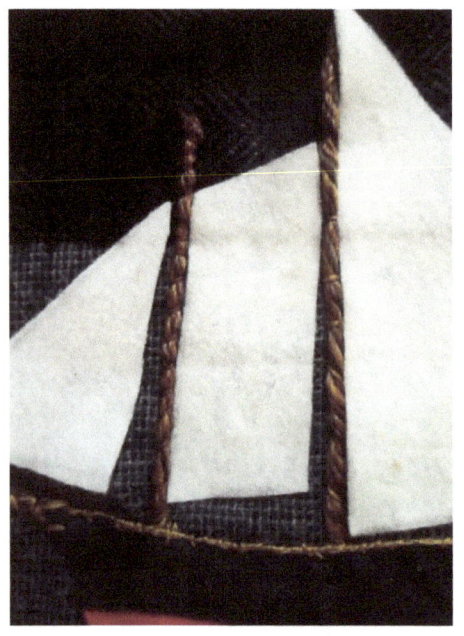 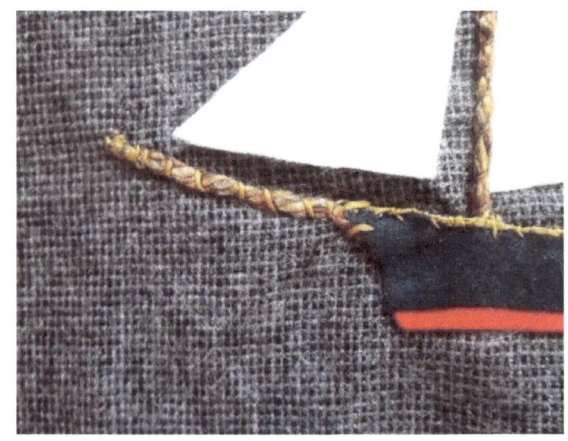

Detail, details

Now, begins the story. Folk art always tells a story, and this one is about a ship, a whale and three mermaids, Mother Mermaid, Baby Mermaid and Auntie Mermaid. Whales and Mermaids have always been friends, helping one another to survive by escaping capture by whalers and lustful sailors.

Whether telling your story on canvas or wool, it is the details that impart the tale. Detailing on wool calls for a variety of different types and thicknesses of thread and yarn. It is these materials that help you to "paint" the details.

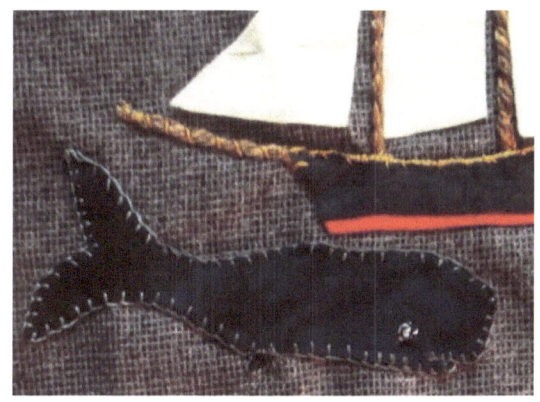
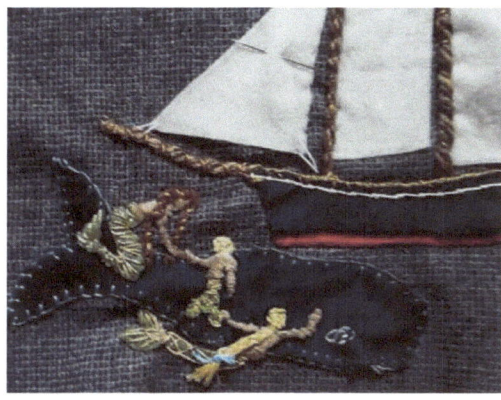

Climb Aboard Little Mermaid
Ready to be blocked and framed

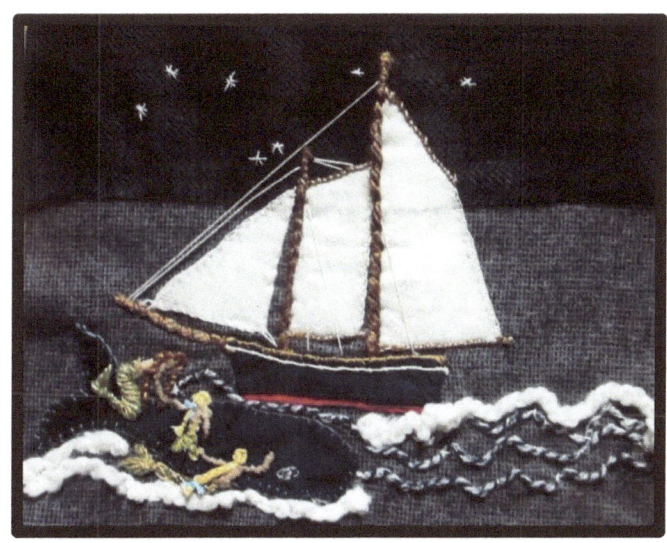

Note: Devise a way to sign your Sailors Woolies, either by stitching your initials onto the piece or adding a personal card on the back of the framed piece. History will thanks you!

Part II
Penny Ruggs

Wool, wool, lovely wool...waste not, want not

Penny Ruggs (old spelling) appeared in homes around the time of the Civil War. Thrifty homemakers used up leftover wool using pennies as templates...sometimes a penny was sewn in to make a table mat stay put. Burlap feed sacks made fine backings and the whole was blanket stitched around the edges. Nothing was ever wasted by the women of their time who were, by necessity, dedicated recyclers. We can all take a lesson from the frugal women who created beauty from the scraps left from utilitarian work to make spots of color and charm for their simple home.

At a time when women spun the wool (perhaps even herded and sheared the sheep), wove the fabric, and made the family's clothing, blankets and outerwear, nothing was ever wasted. Therefore, only the scraps of wool too small to be used in a practical way were turned into things of beauty for the home. Only in this way could women rationalize adding touches of color and charm to brighten their often drab and hardworking existence.

Penny rugs were never meant to be floor rugs: hooked and braided rugs played that important role. Instead, the penny rug technique was principally used in creating bed covers, and table runners. Most early designs included "pennies", circles cut around the one-cent coin of the time that was over five times heavier and almost 50% larger than its contemporary counterpart. As Penny Ruggs became more popular, images of animals appeared (the cat was the most common Penny Rugg image...that reliable ratter every home employed), as well as flowers, birds and geometric shapes. Stars and hearts appear in many old Penny Ruggs. "Fingers" sewn around the edge of a rugg has long been a finishing technique. Blanket stitches prevailed however, ambitious women who knew their embroidery stitches created more intricately decorated ruggs that featured a variety of intricate stitches. The choice is yours.

Working with wool can be a meditative experience. It is a pleasant tactile activity as well as being pleasing to the eye.

This Penny Rugg pays homage to the frugal women who might have done as I did and used the best portion of a heavy old wool blanket for the base. The rest of the blanket was too worn and torn to save, except for scraps, to be used for pennies. Being a pack rat is an important qualification for working with wool. This blanket scrap harkens back to my childhood when we all crawled under heavy wool blankets to watch television because our old sea captains house was heated only by a living room wood stove and a kitchen woodstove.

Use it up, wear it out, make it do.

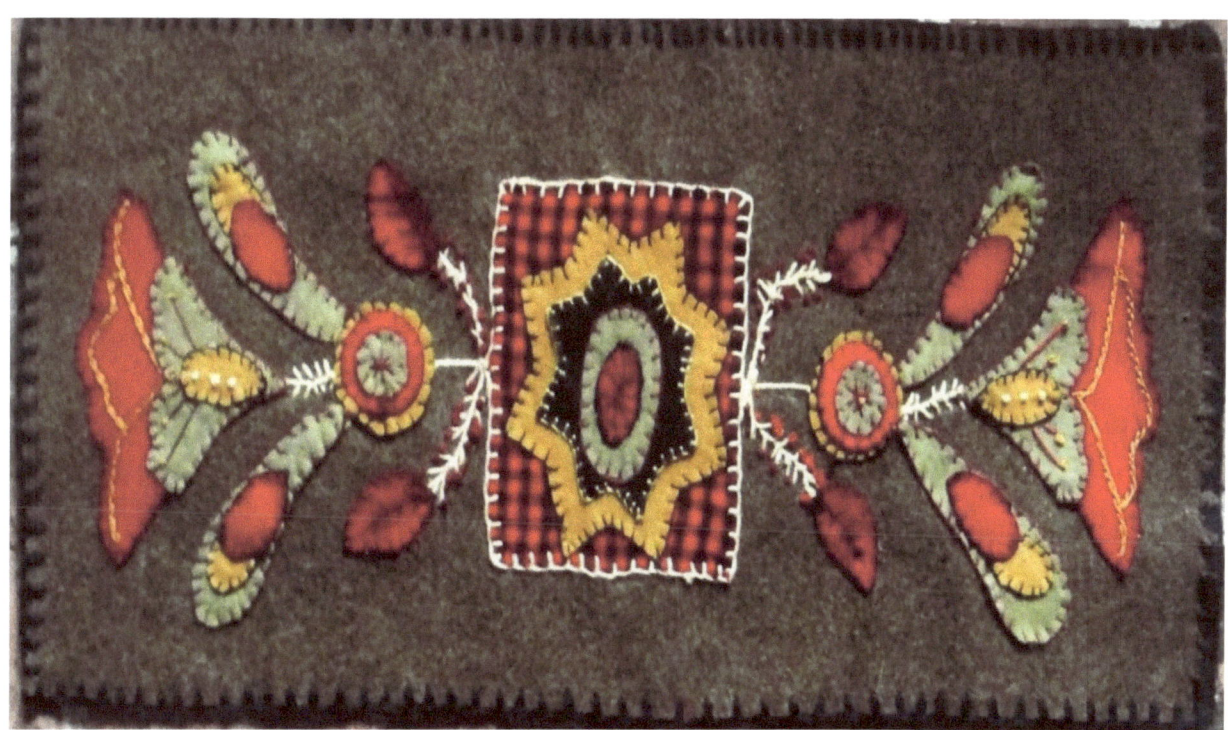

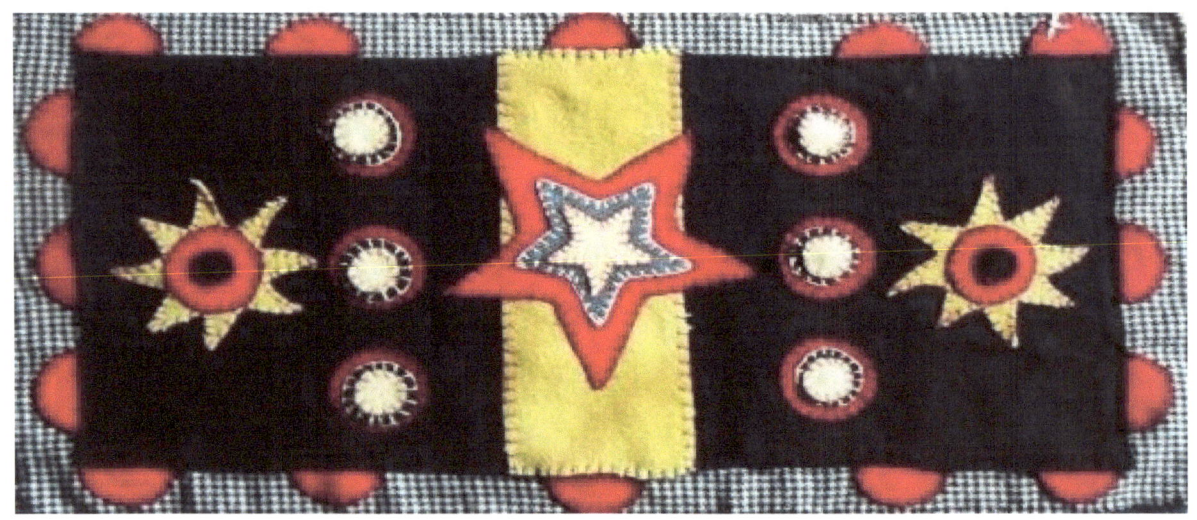
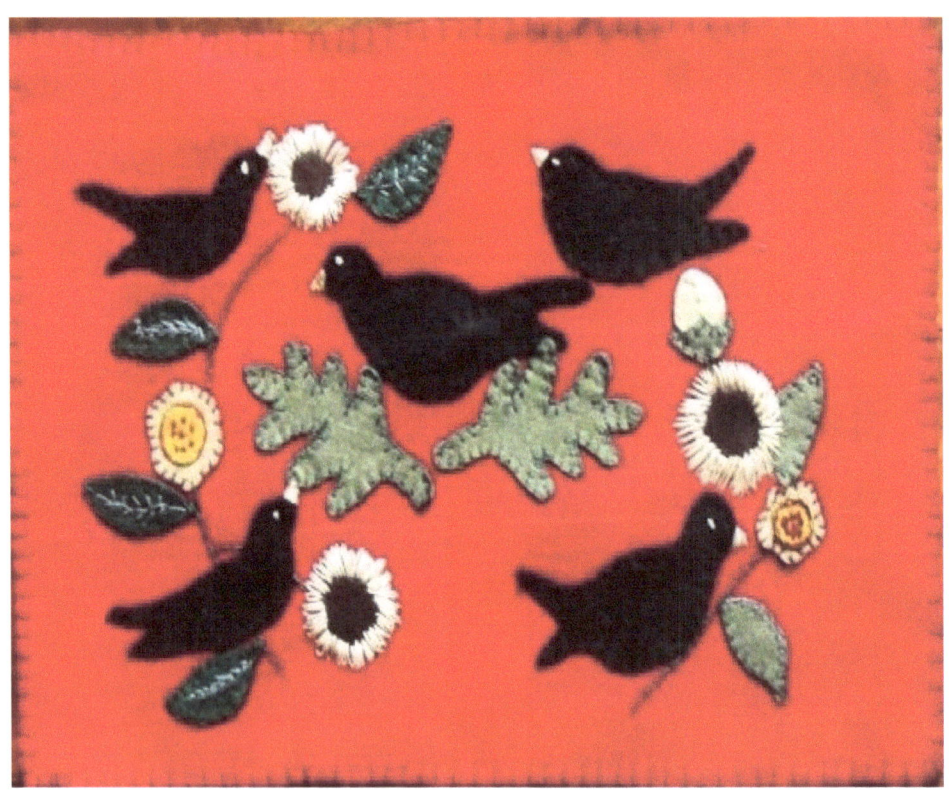

The Eternal Magic of Black

Keep on hand lots of black wool and felt.

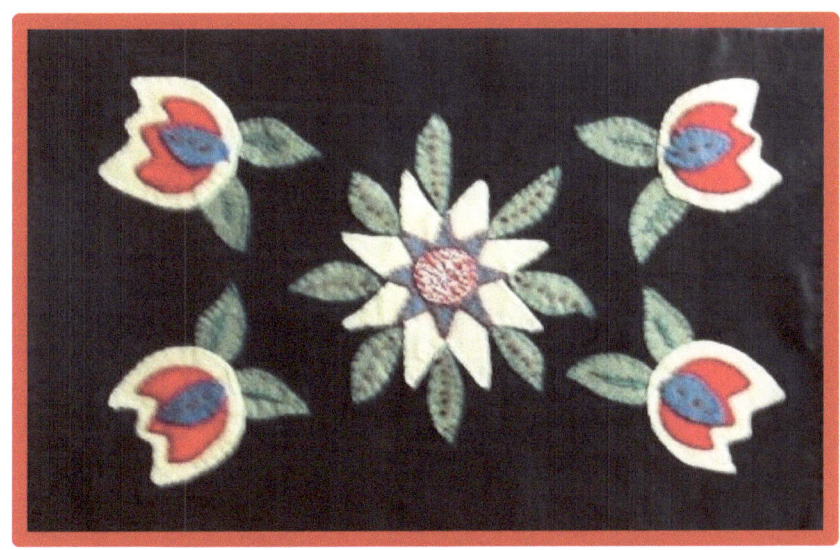

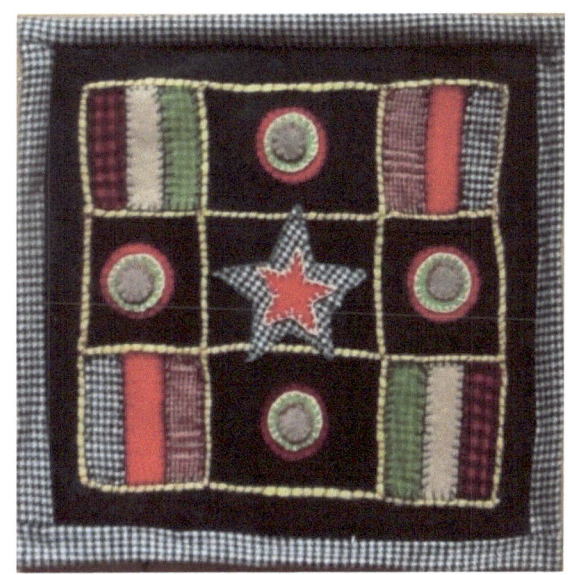

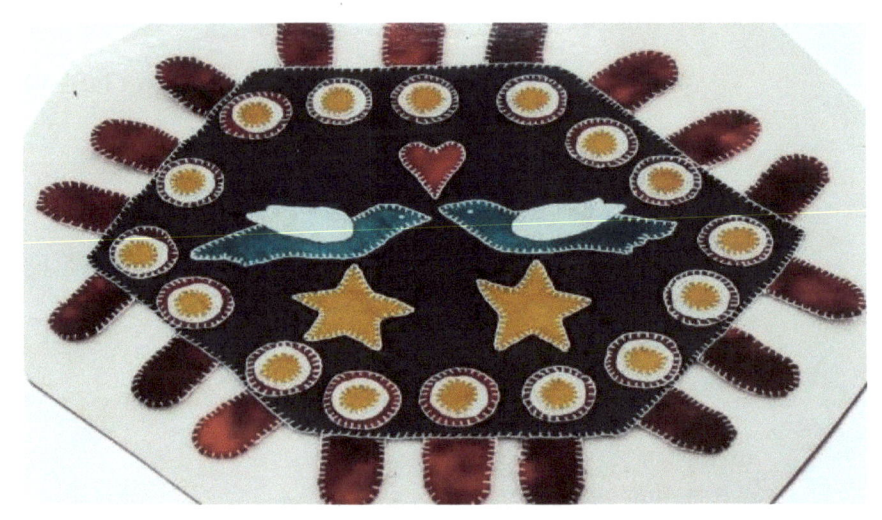

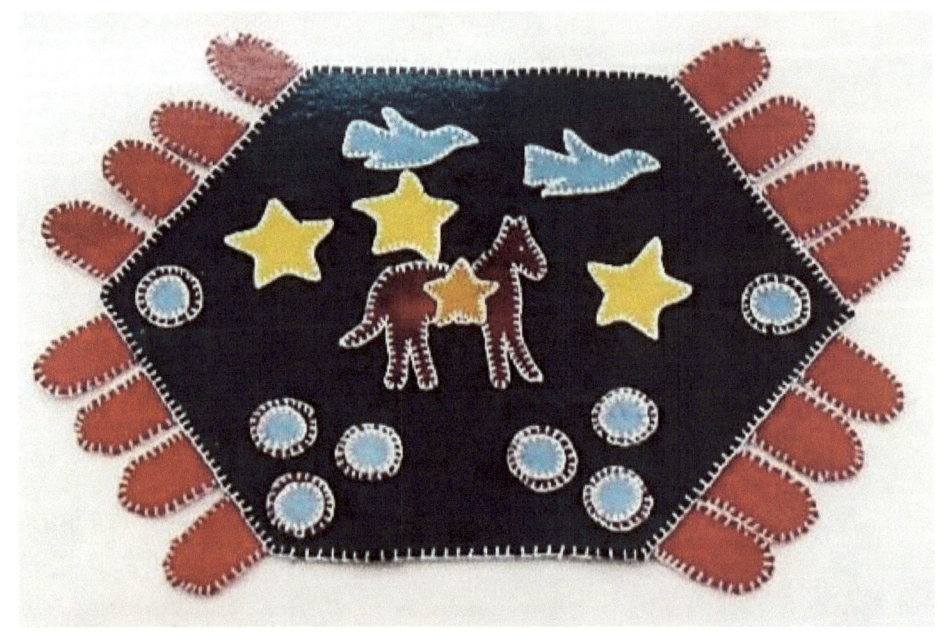

Americana Hooked Rugs

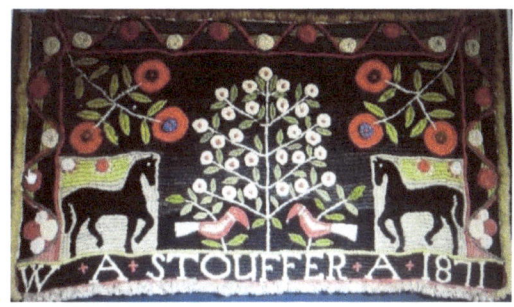

The author William Winthrop Kent believed that the earliest forebears of hooked rugs were the floor mats made in Yorkshire, England during the early part of the 19th century. Workers in the weaving mills were welcome to take home what were called thrums, or pieces of yarn too small for weaving. Women figured out that they could use these "useless" pieces of wool by pulling them through a backing with a hook, most likely the backing being old burlap feed and seed bags, to make floor coverings. Badly needed in unheated or poorly heated homes, some just simple shacks, these by-products of weaving were much appreciated by the poor. Over time, creative weavers of hooked rugs improved the look of these rugs with designs rather than haphazard finishes. Creative Recycling!

In the publication "Rag Rug Making" by Jenni Stuart-Anderson, Stuart-Anderson states that the most recent research indicates "...the technique of hooking woolen loops through a base fabric was used by the Vikings, whose families probably brought it to Scotland." To add to this there are sound examples at the Folk Museum in Guernsey, Channel Islands that early rag rugs made in the same manner where produced off the coast of France as well.

Rug hooking as we know it today may have developed in North America, specifically along the Eastern Seaboard in New England, the Canadian Maritimes, and Newfoundland and Labrador. In its earliest years, rug hooking was a craft of poverty. The vogue for floor coverings in the United States came about after 1830 when factories produced machine-made carpets for the rich, and the poor had to improvise. Much creativity results from the need to improvise. British Sailors Woolies, Penny Ruggs and Hooked Rugs are with us today because people, mostly women, took advantage of what was available to them in order to make things of utility that eventually morphed into beauty. The need for beauty is intrinsic in us all. Years later, understandably, these beautiful objects often moved from the floor to the wall. Saving old hooked rugs by taking them away from harm from foot traffic is an opportunity to have wonderful wall art.

Horses, Horses, Horses

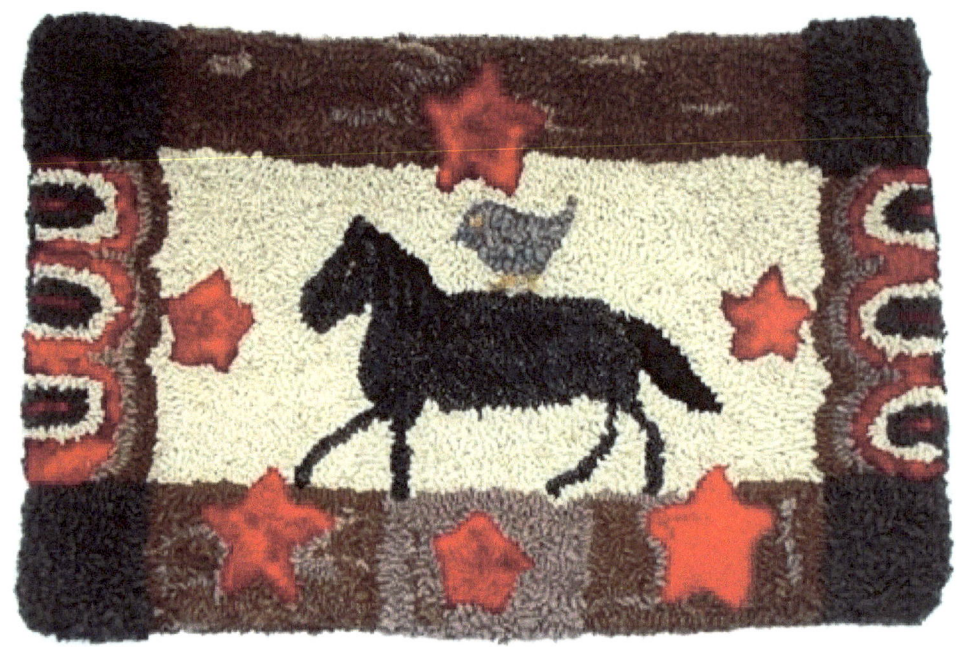

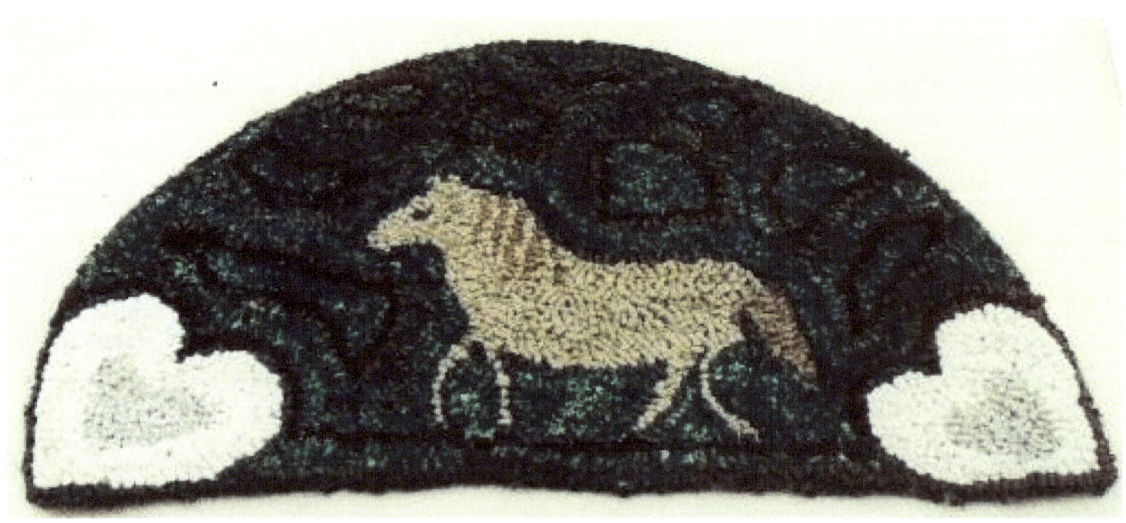

Field & Stream

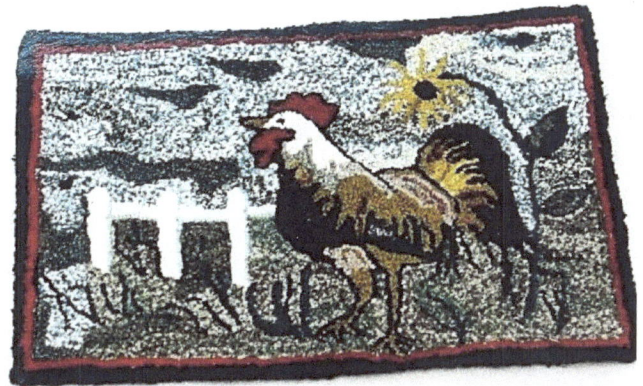

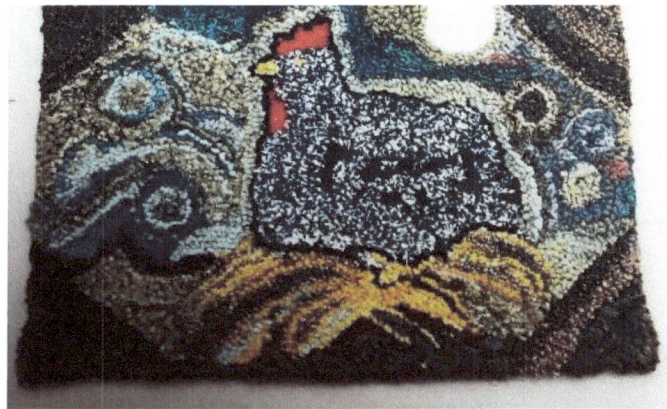

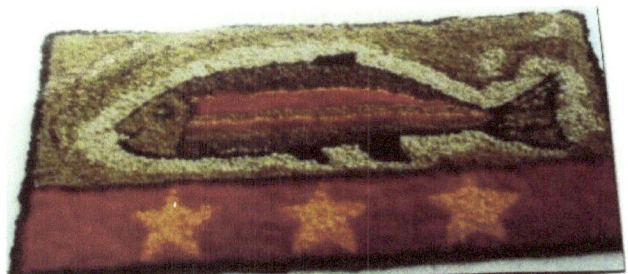

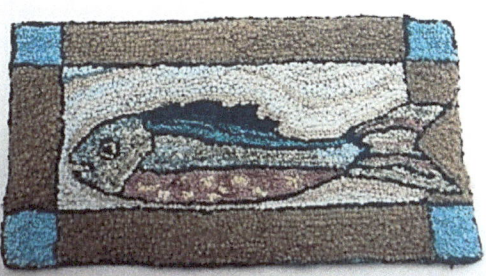

Homes by the sea, homes in the woods

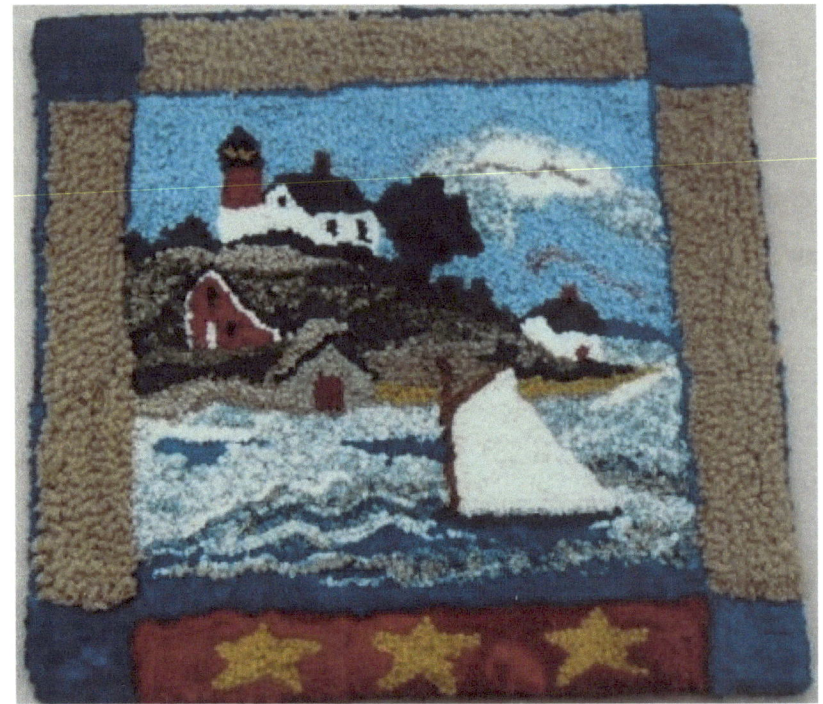

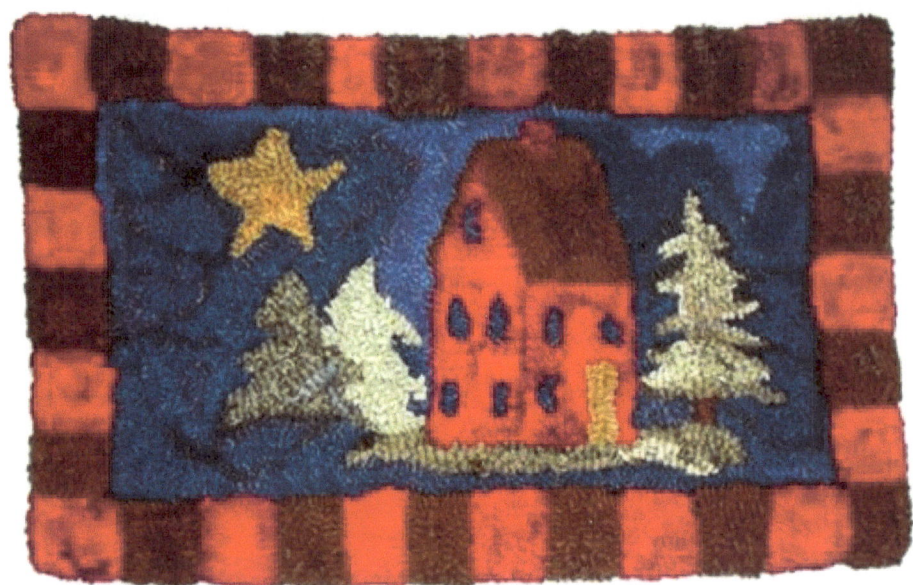

The Welcome Mat

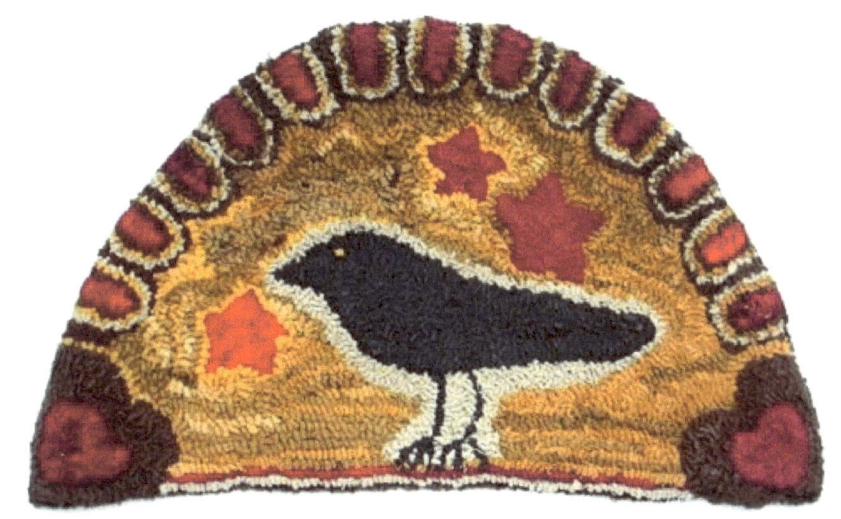

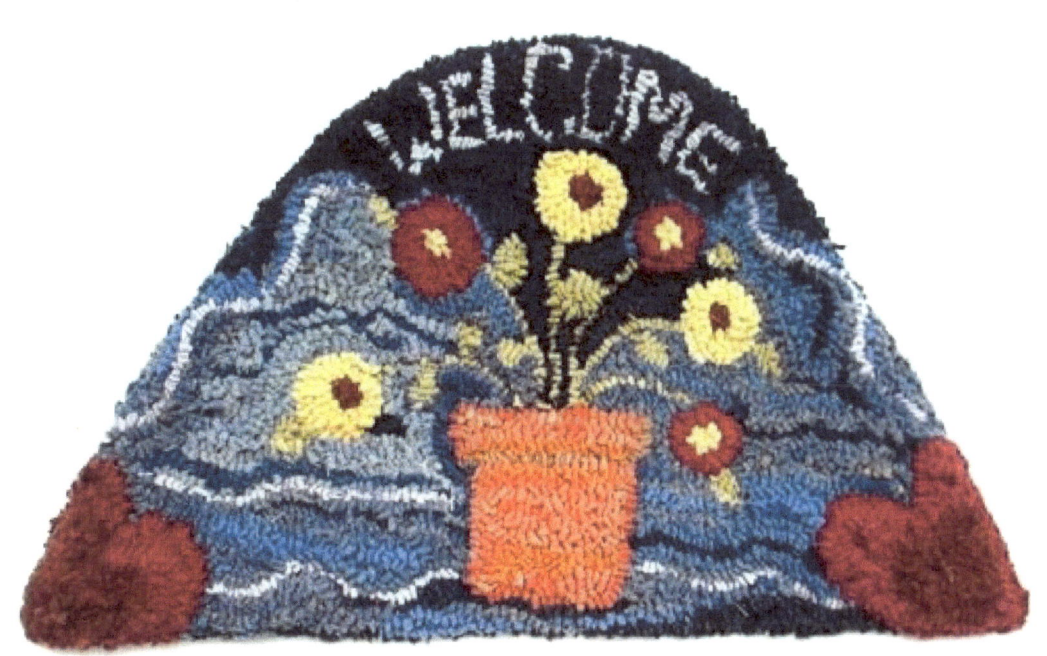

I can never resist a rug with stars

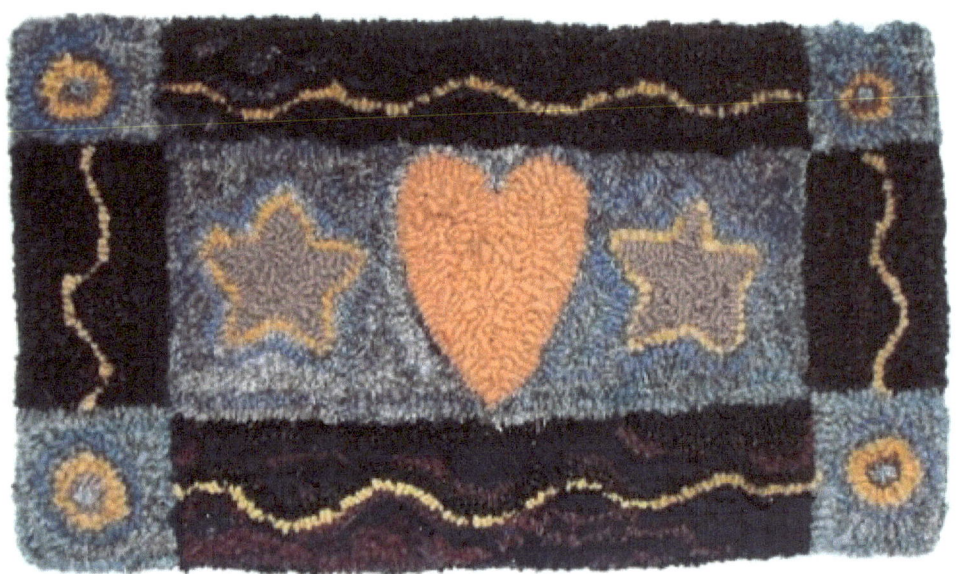

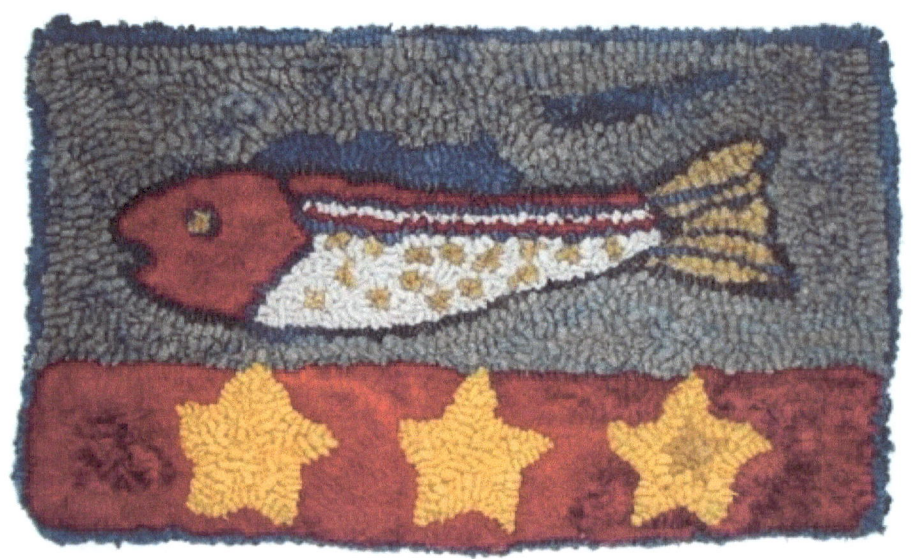

 May the force of all the talented wool artists down through the ages be with you to guide your heart and hands as you create the design, dye the wool, cut the paper patterns & wool shapes, tug the hook through the backing, cut the "pennies", stitch, stitch, stitch, and love every minute of the wool art that is uniquely yours.

 If you have enjoyed this book, please tell a friend. Spread the word about the joys of working with wool to make art.

 Thanks for visiting.

Cynthia

 A transplanted Cape Cod and Nantucket wool artist enjoying a new love affair with coastal Down East Maine

www.ingramcontent.com/pod-product-compliance
Lightning Source LLC
Chambersburg PA
CBHW051100180526
45172CB00002B/709